Edward Weston

Edward Weston

edited by
Filippo Maggia

SKIRA

Art director
Marcello Francone

Design
Luigi Fiore

Editorial Coordination
Eva Vanzella

Editing
Emanuela di Lallo

Layout
Fayçal Zaouali

Translation
Sylvia Adrian Notini

First published in Italy in 2012 by
Skira Editore S.p.A.
Palazzo Casati Stampa
via Torino 61
20123 Milano
Italy
www.skira.net

Printed and bound in Italy.
First edition

ISBN: 978-88-572-1633-1

Distributed in USA, Canada,
Central & South America by
Rizzoli International Publications,
Inc., 300 Park Avenue South,
New York, NY 10010, USA.
Distributed elsewhere in the
world by Thames and Hudson
Ltd., 181A High Holborn, London
WC1V 7QX, United Kingdom.

Catalogue

Chief Editor
Filippo Maggia

Texts by
Chiara Dall'Olio
Filippo Maggia

Editorial Coordinator
Francesca Lazzarini

Acknowledgements
Michelina Borsari, festival*filosofia*
Center for Creative Photography,
The University of Arizona, Tucson,
Arizona
Richard Gadd, Weston Gallery,
Carmel, California
Sandra Phillips, San Francisco
Museum of Modern Art
Maggie Weston
Matthew and Davika Weston

This volume has been published
under the auspices of

on the occasion of the exhibition
"Edward Weston. A Retrospective"
Modena, former Sant'Agostino
Hospital
September 14 – December 9, 2012

Contents

Filippo Maggia

The Talent of Edward Weston

Sources
All quotations from the private
correspondence
of Edward Weston.

The intelligence of Edward Weston transpires in each and every phase of his existence: the way he approached life is visible in his ability to rationally follow his instincts with the discipline required to do so, without, however, bowing to mental constraints. Weston was open to the world, inquisitive, yet also critical. He was generous, passionate, and lucid to the point that he sometimes seemed cynical.

Weston immediately understood just how important and crucial it was to have a knowledge of the camera to be able to reproduce the forms of reality without artifices, fully aware that those forms must first find their aesthetic completeness in the mind: "Those who feel nothing, or not completely at the time of exposure, relying upon subsequent manipulation to reach an unpremeditated end, are predestined to failure."

Inquisitiveness, which is a typical trait of photographers, led him to explore the emerging artistic tendencies of his day (such as Cubism), to look towards and examine other cultures (Japan and the Modernism as expressed by the photographers of the Rising Sun), to settle in other countries (Mexico) in order to breathe in the revolutionary climate of those years with all its contradictions and excesses, sharing his daily life with emerging local artists, and the sounds of Surrealism echoing from a Europe that was already in turmoil.

Weston's insatiable thirst for stimuli and knowledge, towards things as well as people, accompanied by the allure of the "new," led him to have intense relationships with women who were also his muses, models and especially his companions, both in everyday life and in art. His talent as a photographer consisted precisely in his willingness to see change as a constant source of inspiration as well as a working method: "Vision, sensitive reaction, the knowing of life, all are requisites in those who would direct through the lens forms of universal appeal … maybe only a fragment, but indicating or symbolizing life rhythms."

To achieve this, Weston soon abandoned pictorialism and its "artistic" pretenses, albeit recognizing its importance as a cultural movement. The photographic realism that he aimed for is actually the search for a pure form to express contemporariness, one which needs no labels. "In this day of ever changing values, it is immaterial wheter or not photography can be labeled art … we need photography as a vital contemporary expression."

The real world, when it is already clear before our eyes, and when we are capable of recognizing its shapes, does not require artifices to be reproduced: whether we are dealing with the face of a man or a woman, the *olla* or the *juguete* made by just any native craftsman, an artichoke heart or a pair of mushrooms, it is in our minds that they become proud-looking sculptures, objects that appear to come to life, or vegetables that can be either elegant or indolent. The photographer must represent them the way they are and according to what they signify at that moment: this is why Weston chose the contact print.

In February 1936 Ansel Adams had just come back from a work session in Yosemite National Park. He was ill and from his bed he wrote to his friend and partner in Group *f*/64, who had sent him some of his photographs:

"I can't tell you how swell it was to return to the freshness, simplicity and natural strenght of your photography after such a dose of intellectualism, cynicism, and dialecticism received in the East. ... I am convinced that the only real security lies in a certain communion with the things in the Natural world."

Places are another key element in Weston's experience, because of his ability to feel them and not just spend time there, to absorb them and experience them without losing anything of their lifeblood—even when they don't seem to have any. So, the twisting forms of a steel plant in Ohio have the same relevance as Zabriskie Point, the dunes as the saguaro of Arizona, Mexico as Point Lobos.

And places bring with them female companions who are also models and intellectuals with whom to exchange opinions: models who pose for the photographer, assistants, if not even his biographers. But most of all lovers, who like him feed on strong passions, as we can glean from the letter Tina Modotti wrote in December 1924: "What is the use of words between Edward and I? He knows me and I know him: we both have faith in each other." Soon after she would write up a will in which she bequeathed everything to Weston, including "... furnitures, books, photographs, etc. and all photographic equipment, lenses, cameras, etc." which Weston could keep for himself, and distribute the rest to Modotti's relatives and friends.

Ties that were still strong years later: in January 1931, five years after their separation in Mexico, this was how Tina ended a long letter to Weston—which she wrote from Moscow where she was an illegal immigrant following the events of the Revolution—even though she knew he was with Sonya Noskowiak now: "Dear Edward, if you ever are in the mood for a few words to me, the Berlin address is still good..."

On the first page Weston wrote the words: "Tina's last letter to me."

Works

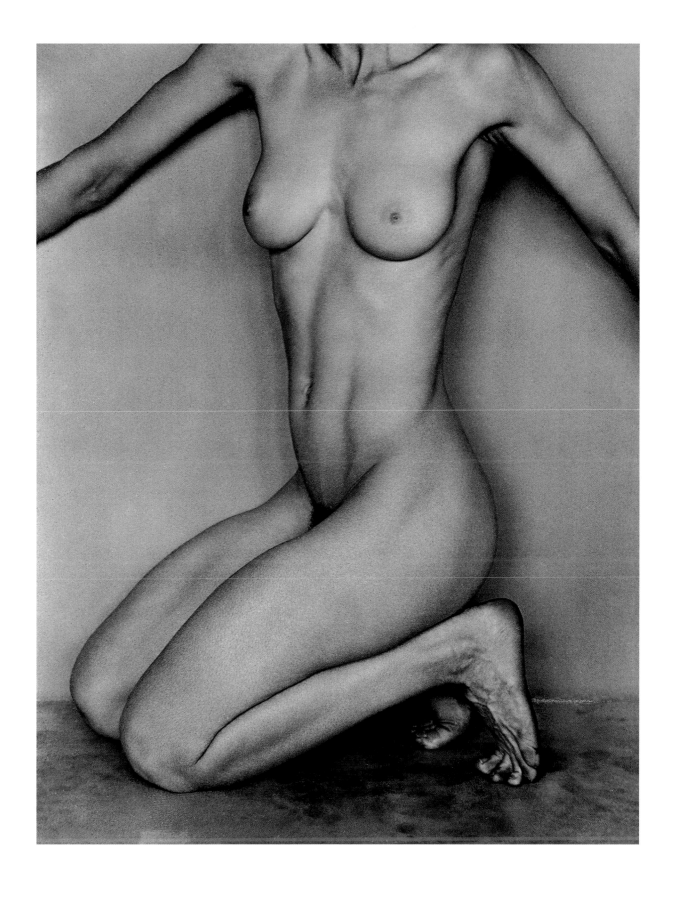

Dancing Nude, 1927
Gelatin silver print
23.1 x 17.9 cm
Center for Creative Photography, University
of Arizona, Edward Weston Archive

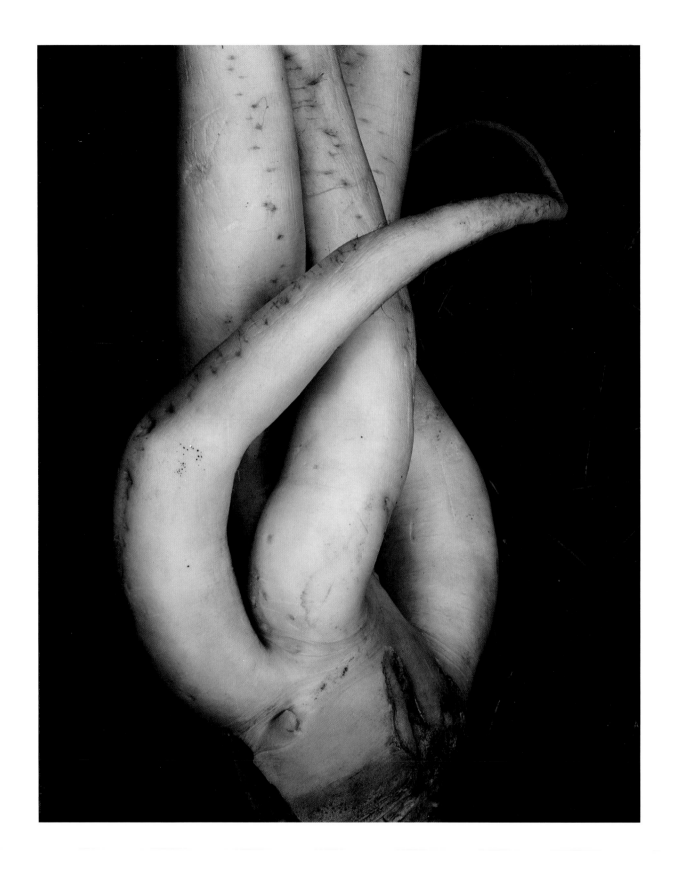

Edward Weston with Sonya Noskowiak
White Radish, 1933
Gelatin silver print
24.1 x 19 cm
Center for Creative Photography, University
of Arizona, Edward Weston Archive

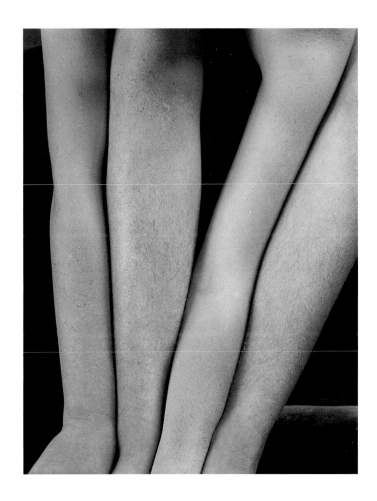

Nude, 1934
Gelatin silver print
11.8 x 9.3 cm
Center for Creative Photography,
University of Arizona, Edward Weston Archive
Printed by Brett Weston, supervised

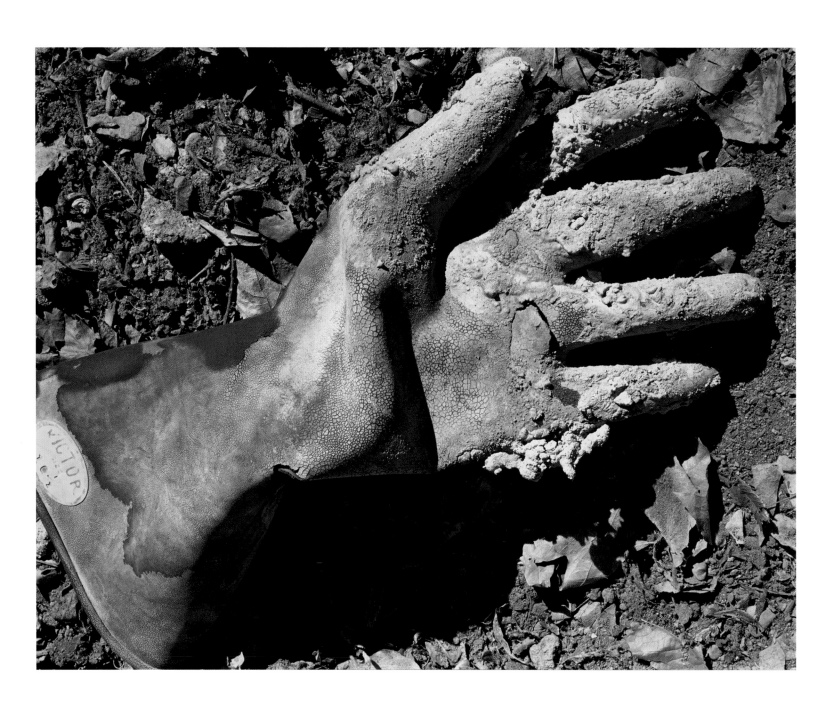

Cement Worker's Glove, 1936
Gelatin silver print
19.1 x 24.2 cm
Center for Creative Photography, University
of Arizona, Edward Weston Archive

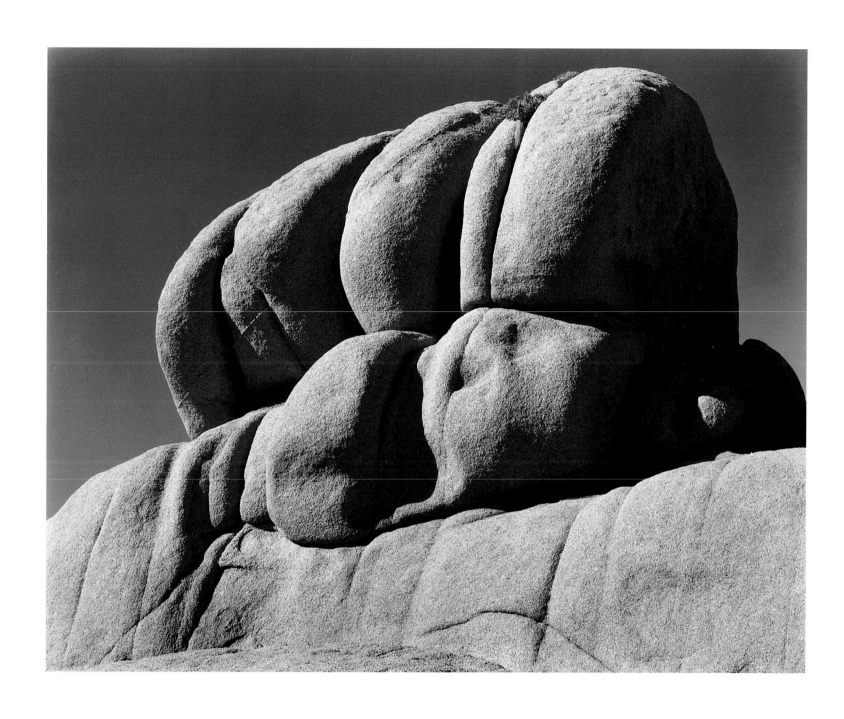

Wonderland of Rocks, 1937
Gelatin silver print
19.1 x 24.3 cm
Center for Creative Photography, University
of Arizona, Edward Weston Archive

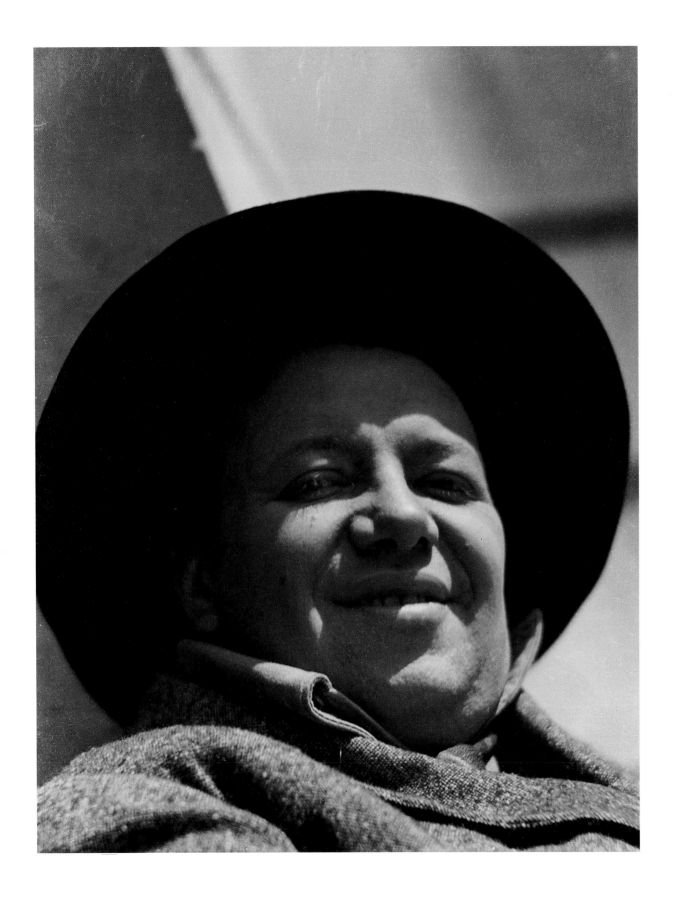

Diego Rivera, Mexico, 1924
Gelatin silver print
24 x 19.1 cm
Center for Creative Photography, University
of Arizona, Edward Weston Archive

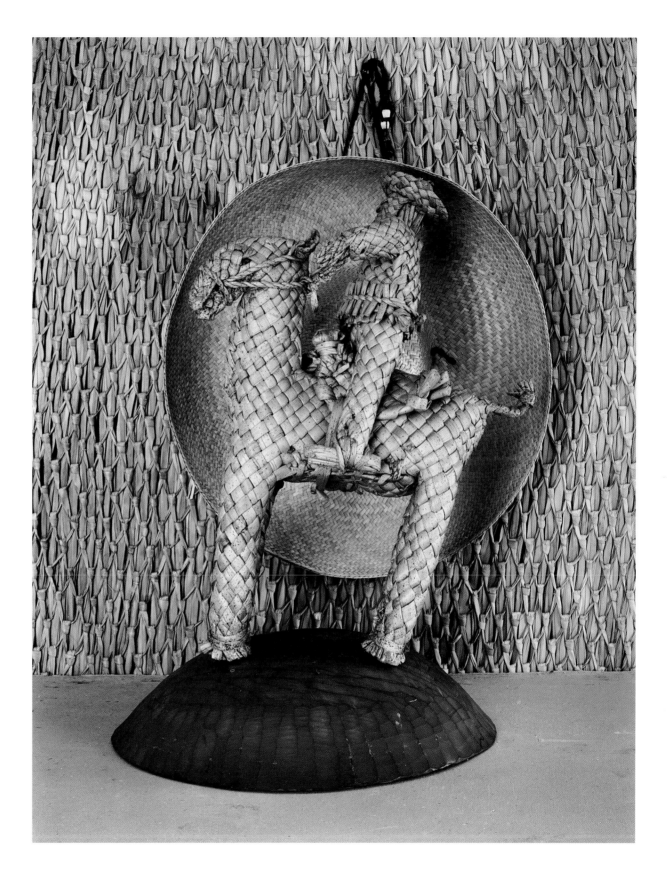

Juguetes, Panchito Villa, 1926
Gelatin silver print
23.9 x 19.1 cm
Center for Creative Photography, University
of Arizona, Edward Weston Archive
Printed by Brett Weston, unsupervised

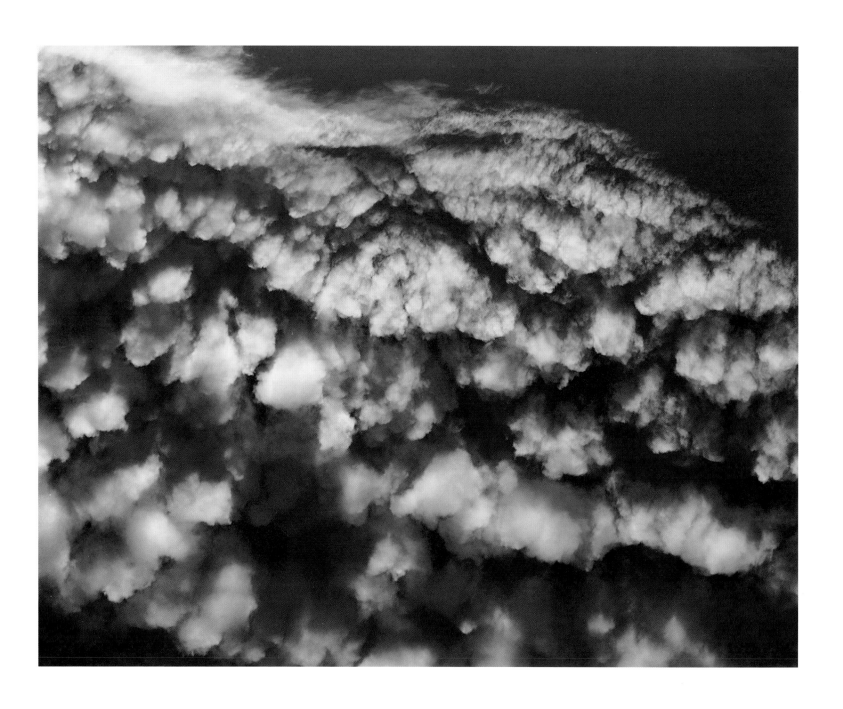

Cloud, 1936
Gelatin silver print
19.3 x 24.5 cm
Center for Creative Photography, University
of Arizona, Edward Weston Archive

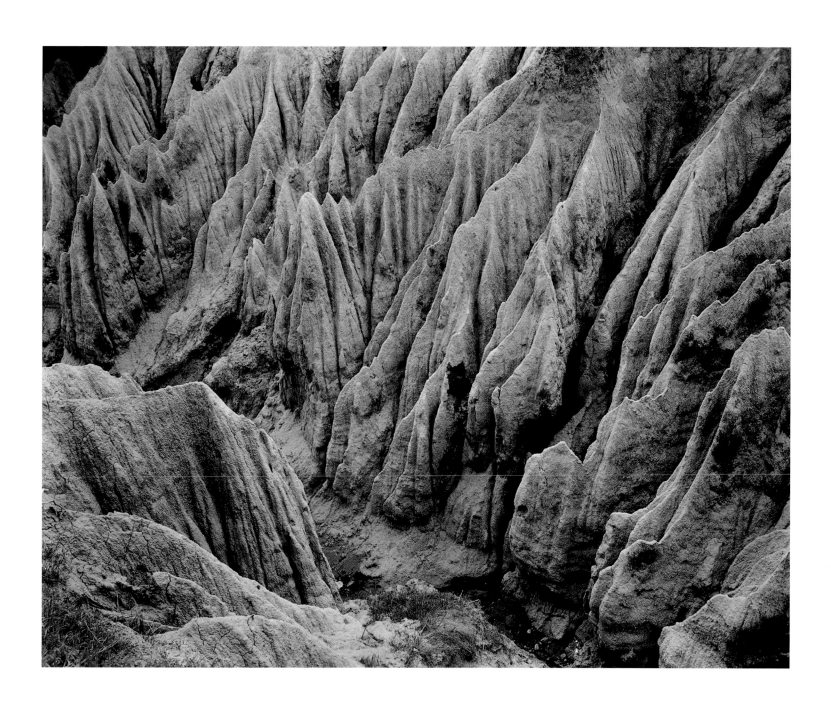

Carmel Valley, 1932
Gelatin silver print
19.2 x 24.2 cm
Center for Creative Photography, University
of Arizona, Edward Weston Archive

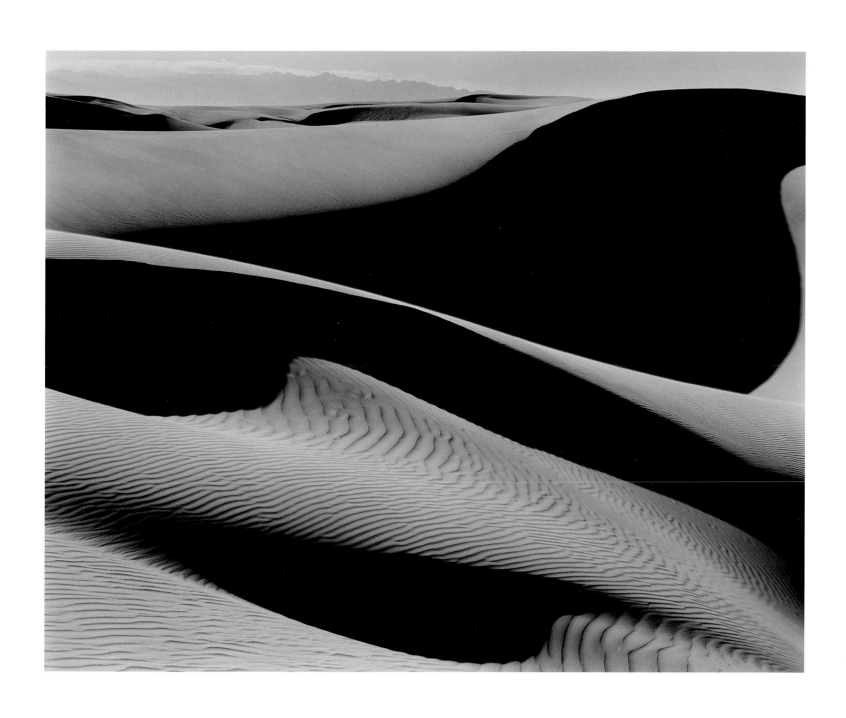

Dunes, Oceano, 1936
Gelatin silver print
19.2 x 24.2 cm
Center for Creative Photography,
University of Arizona, Edward Weston Archive
Printed by Brett Weston, supervised

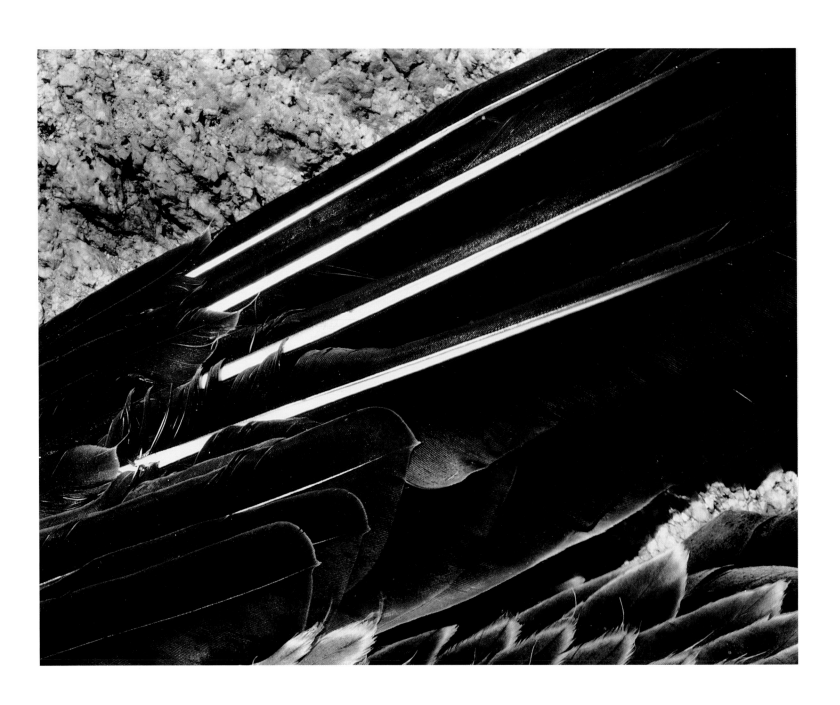

Pelican's Wing, 1931
Gelatin silver print
19 x 23.7 cm
Center for Creative Photography, University
of Arizona, Edward Weston Archive, Gift
of the Heirs of Edward Weston
Printed by Brett Weston, supervised

26

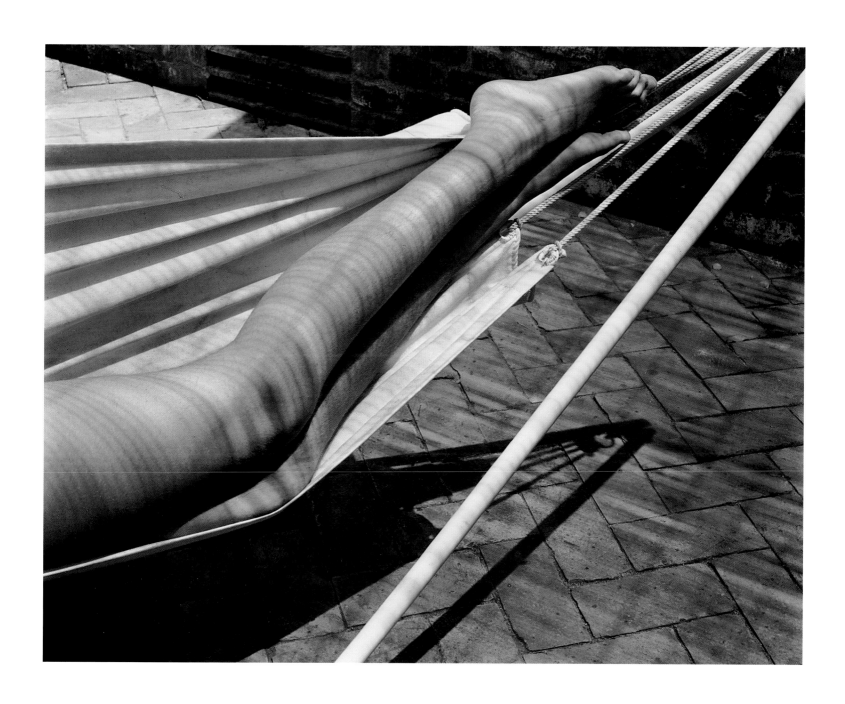

Legs in Hammock, 1937
Gelatin silver print
19 x 24.1 cm
Center for Creative Photography, University
of Arizona, Edward Weston Archive
Printed by Cole Weston, supervised

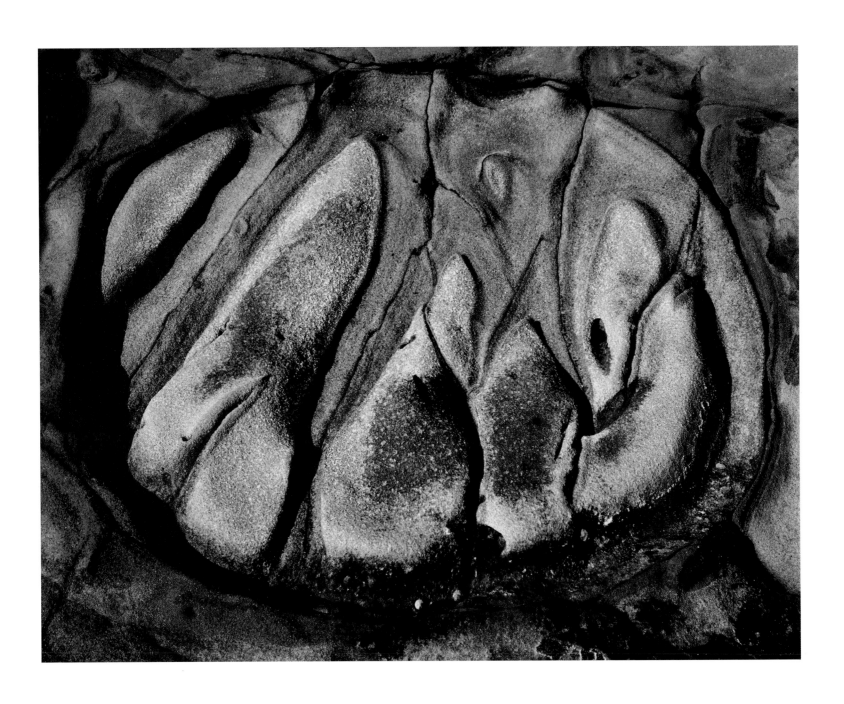

Eroded Rock, Point Lobos, 1929
Gelatin silver print
19.2 x 24.3 cm
Center for Creative Photography, University
of Arizona, Sonya Noskowiak Collection,
Gift of Arthur Noskowiak

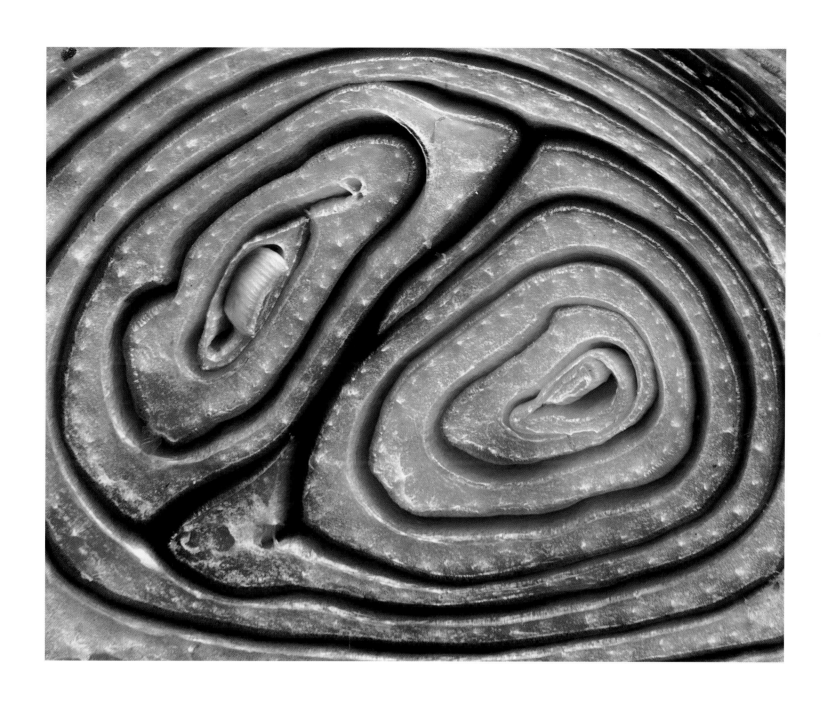

Onion–Halved, Carmel, 1930
Gelatin silver print
19 x 24.1 cm
Center for Creative Photography, University
of Arizona, Edward Weston Archive
Printed by Brett Weston, supervised

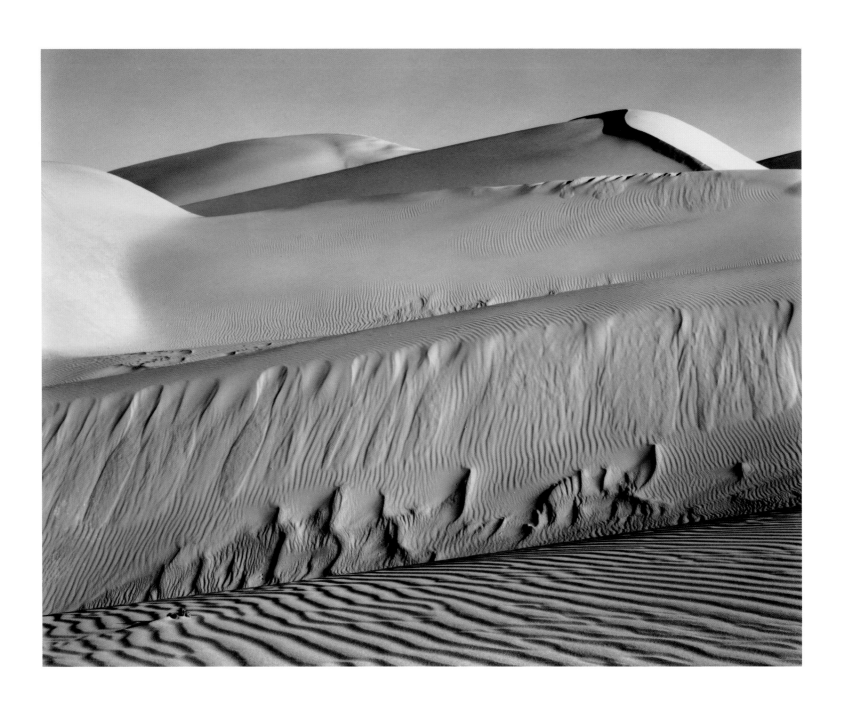

Dunes, Oceano, 1936
Gelatin silver print
19.2 x 24.4 cm
Center for Creative Photography, University
of Arizona, Edward Weston Archive
Printed by Brett Weston, supervised

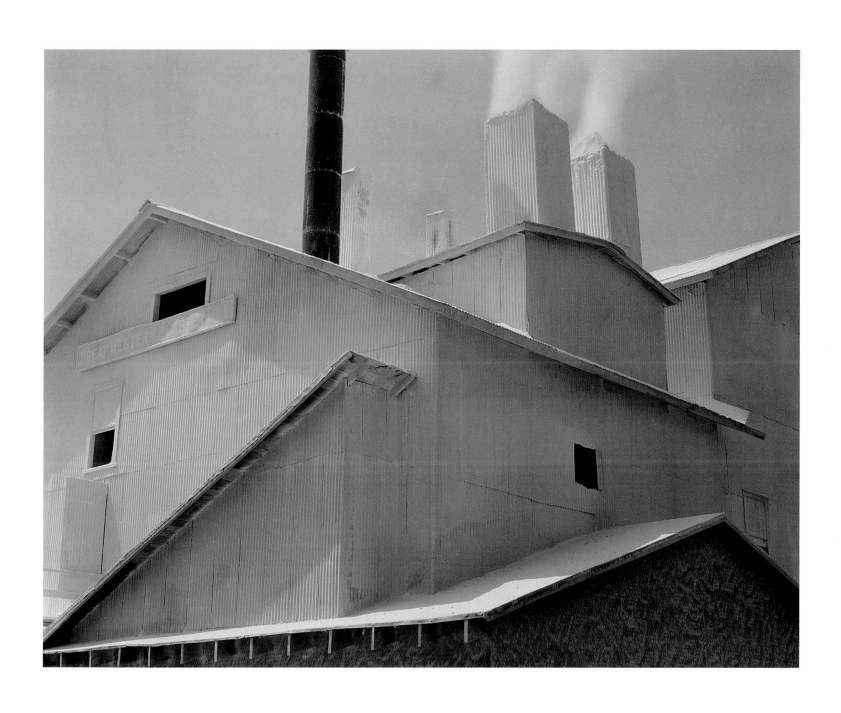

Plaster Works, Los Angeles, 1925
Gelatin silver print
19 x 24.2 cm
Center for Creative Photography,
University of Arizona, Edward Weston Archive
Printed by Brett Weston, supervised

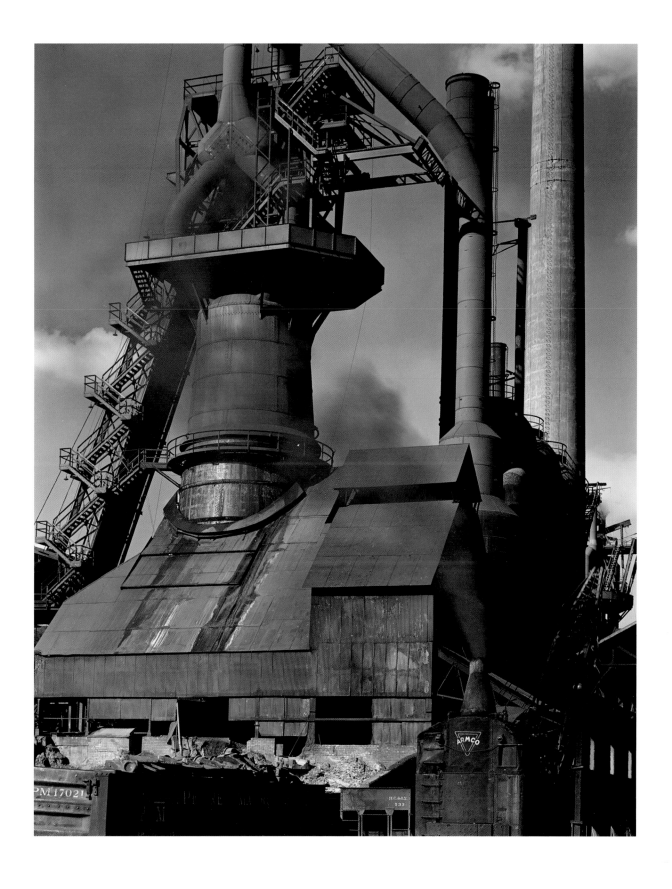

Armco, Middletown, Ohio, 1941
Gelatin silver print
24.3 x 19.3 cm
Center for Creative Photography, University
of Arizona, Gift of Wynn Bullock

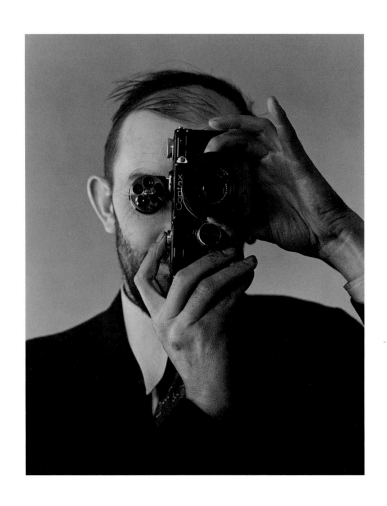

*Ansel Adams (After He Got
a Contax Camera)*, 1936
Gelatin silver print
11.7 x 9.3 cm
Center for Creative Photography, University
of Arizona, Gift of Ansel and Virginia Adams

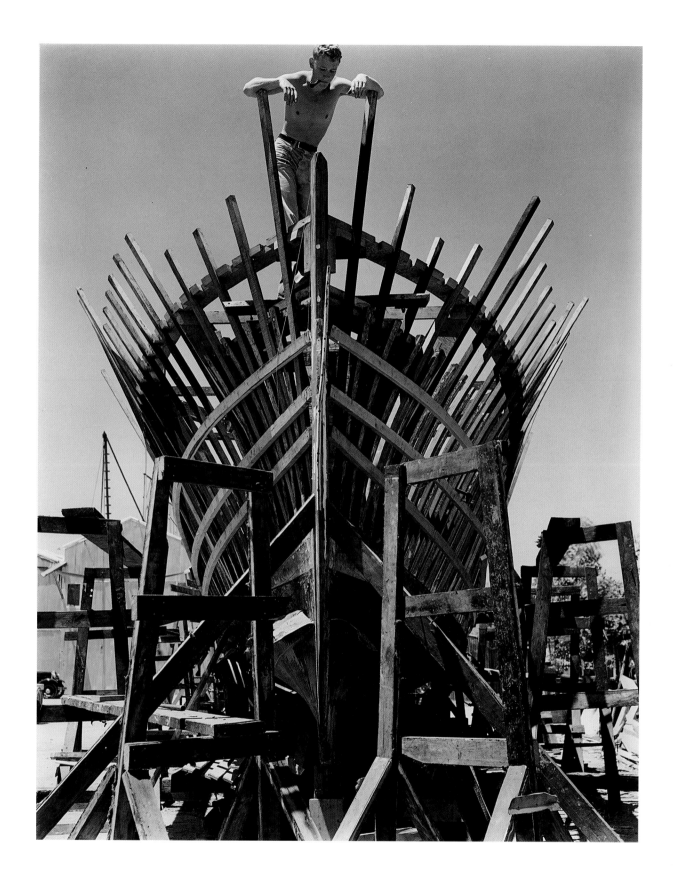

Boat Builder, Wilmington, 1935
Gelatin silver print
24.2 x 19.1 cm
Center for Creative Photography, University
of Arizona, Edward Weston Archive

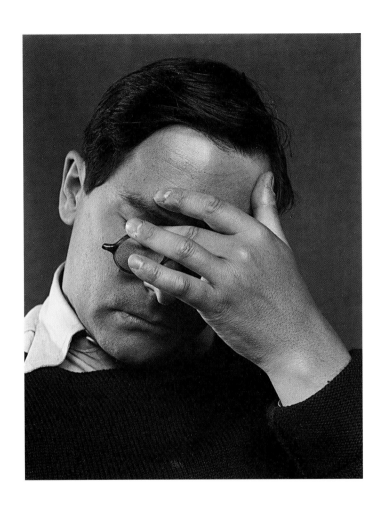

Jean Charlot, 1933
Gelatin silver print
11.8 x 9.2 cm
Center for Creative Photography, University
of Arizona, Edward Weston Archive

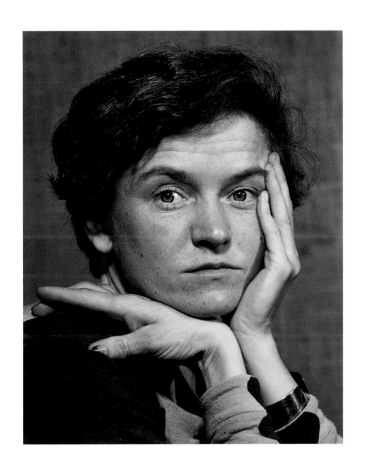

Sonya Noskowiak, 1934
Gelatin silver print
10.9 x 8.7 cm
Center for Creative Photography, University
of Arizona, Sonya Noskowiak Collection,
Gift of Arthur Noskowiak

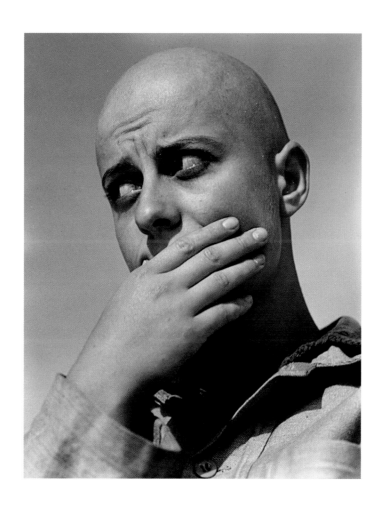

Elinore Stone, 1933
Gelatin silver print
11.8 x 9.2 cm
Center for Creative Photography, University
of Arizona, Edward Weston Archive

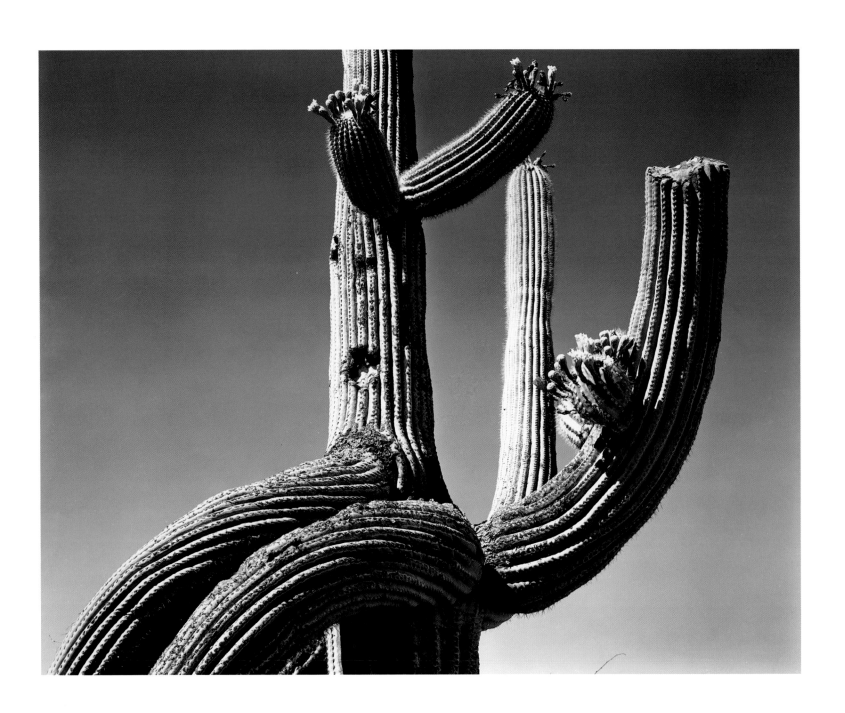

Saguaro, 1941
Gelatin silver print
19.4 x 24.4 cm
Center for Creative Photography, University
of Arizona, Edward Weston Archive

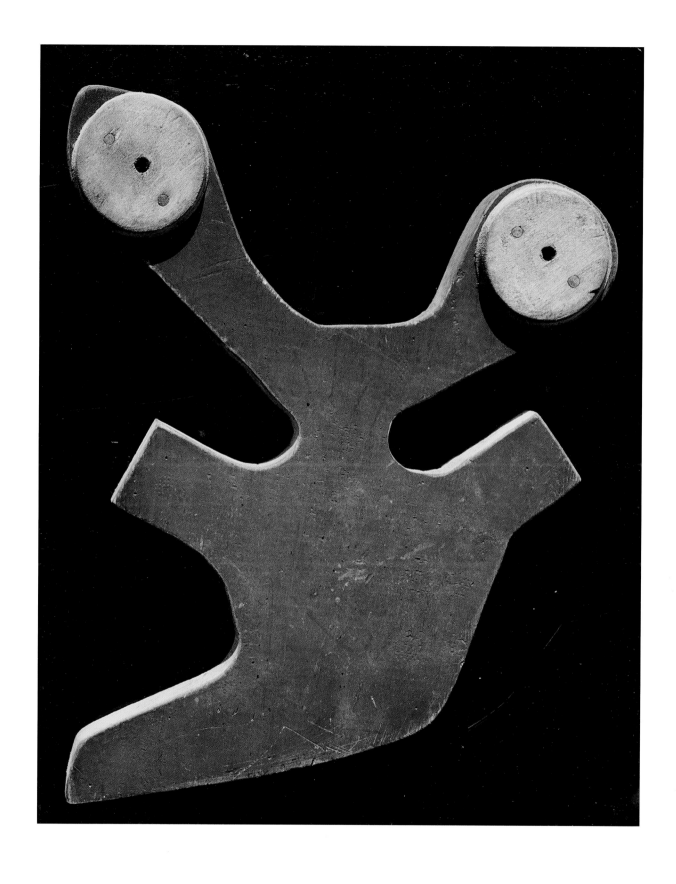

Model for Mould, 1936
Gelatin silver print
24.4 x 19.1 cm
Center for Creative Photography, University
of Arizona, Edward Weston Archive

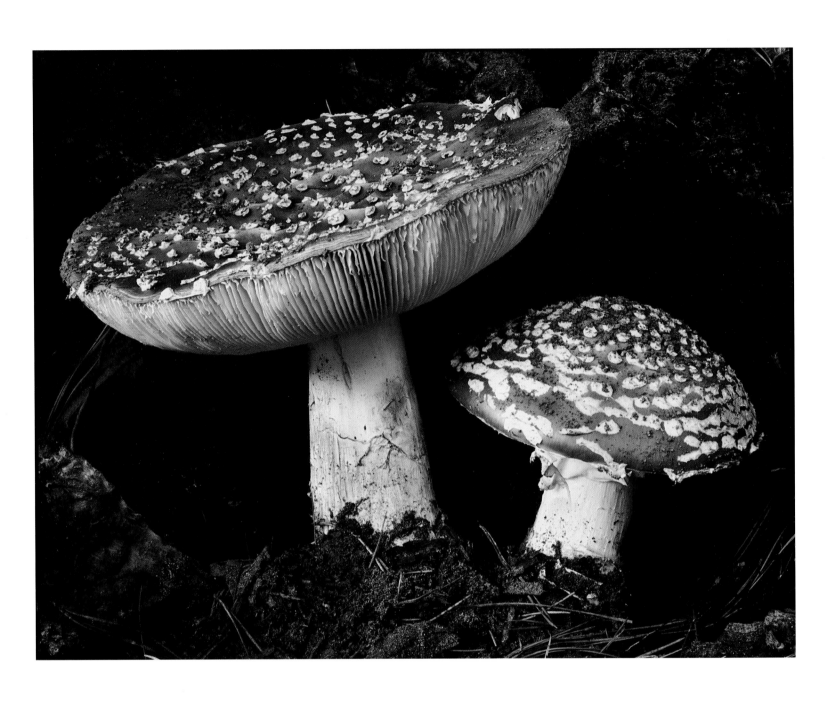

Toadstool, 1934
Gelatin silver print
19.1 x 24.3 cm
Center for Creative Photography, University
of Arizona, Edward Weston Archive
Printed by Brett Weston, supervised

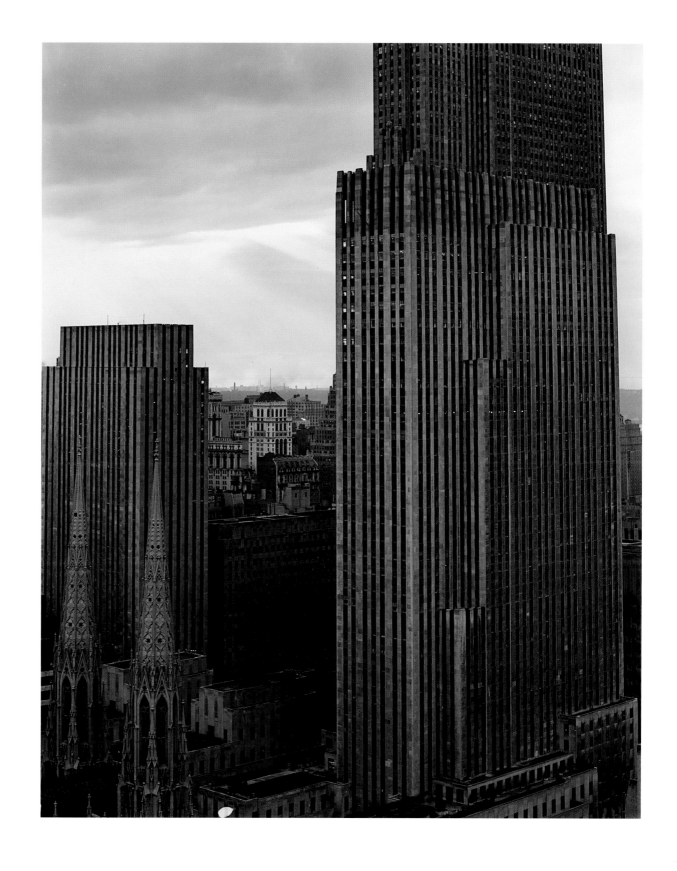

New York, 1941
Gelatin silver print
24.1 x 19.3 cm
Center for Creative Photography, University
of Arizona, Edward Weston Archive

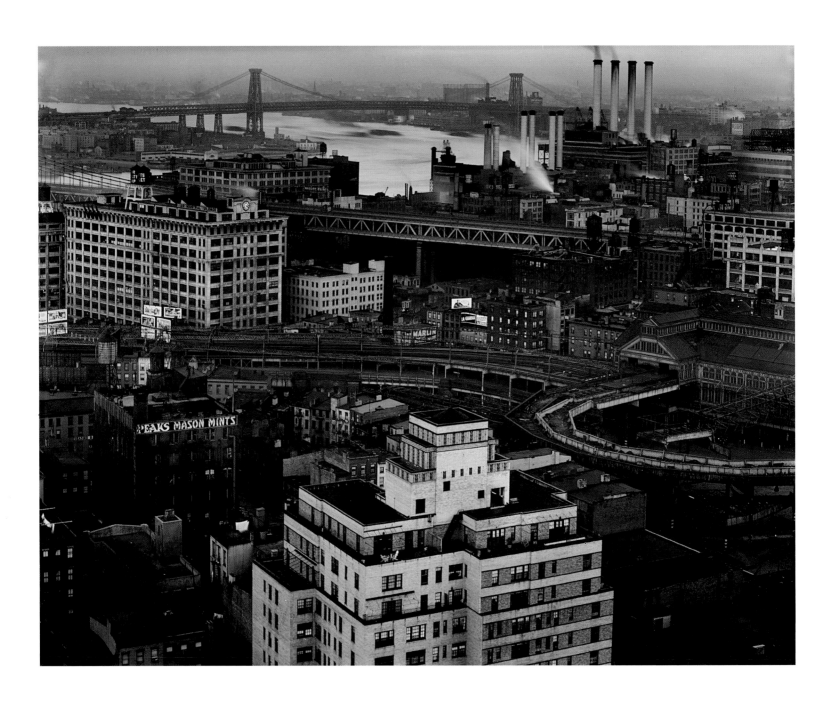

Brooklyn, 1941
Gelatin silver print
19.3 x 24.3 cm
Center for Creative Photography, University
of Arizona, Edward Weston Archive

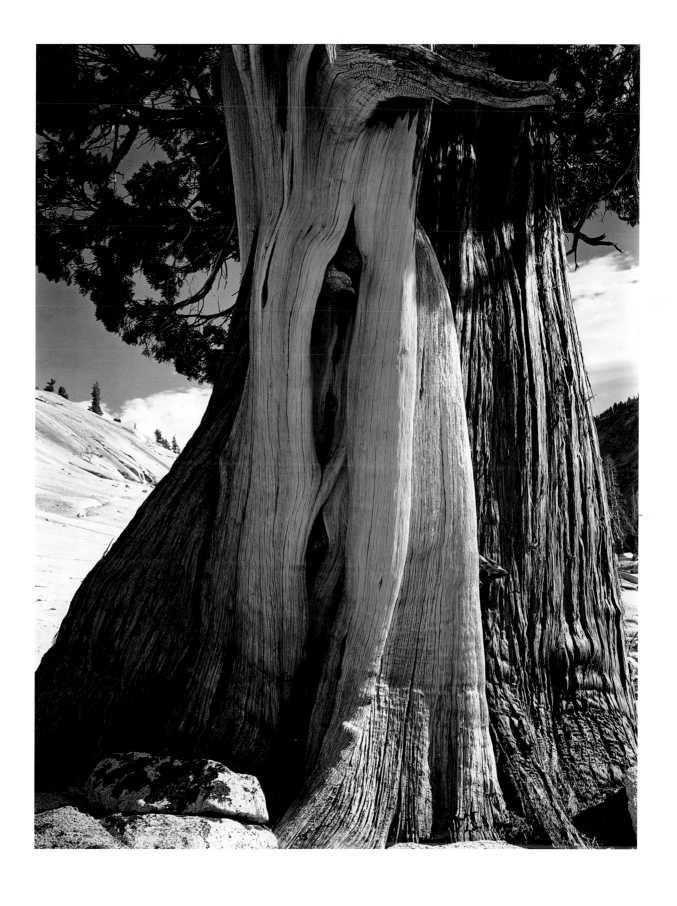

Juniper, Lake Tenaya, 1937
Gelatin silver print
24.1 x 19 cm
Center for Creative Photography, University
of Arizona, Edward Weston Archive

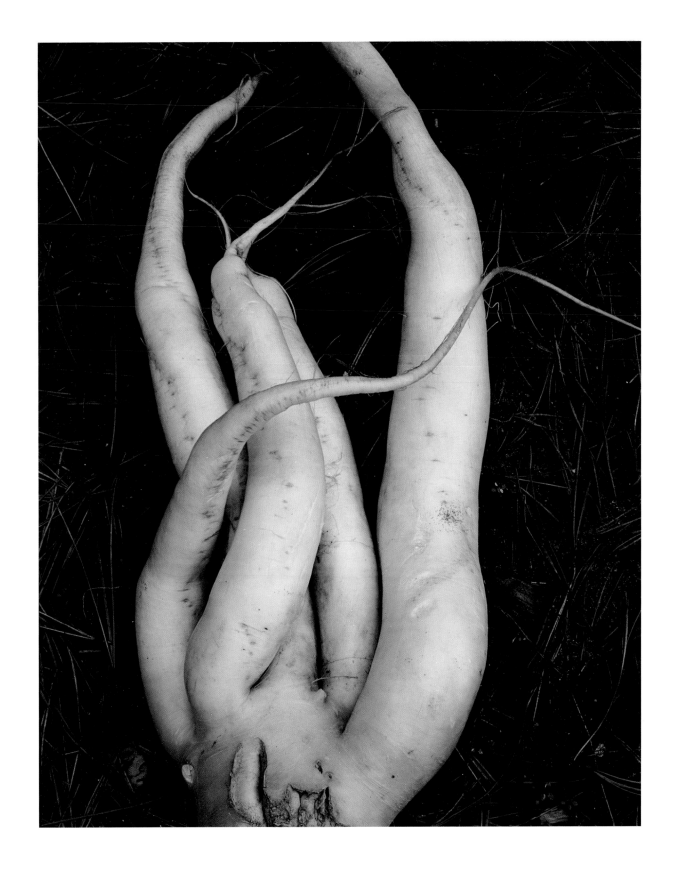

White Radish, 1933
Gelatin silver print
24.2 x 19 cm
Center for Creative Photography, University
of Arizona, Edward Weston Archive

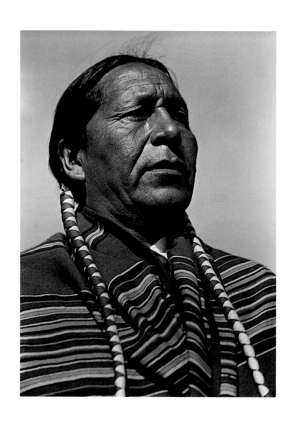

Tony Lujan, 1930
Gelatin silver print
9.7 x 7.2 cm
Center for Creative Photography, University
of Arizona, Edward Weston Archive
Printed by Cole Weston

Three Fish – Gourds, 1925
Gelatin silver print
19.1 x 24.2 cm
Center for Creative Photography, University
of Arizona, Edward Weston Archive
Printed by Brett Weston, supervised

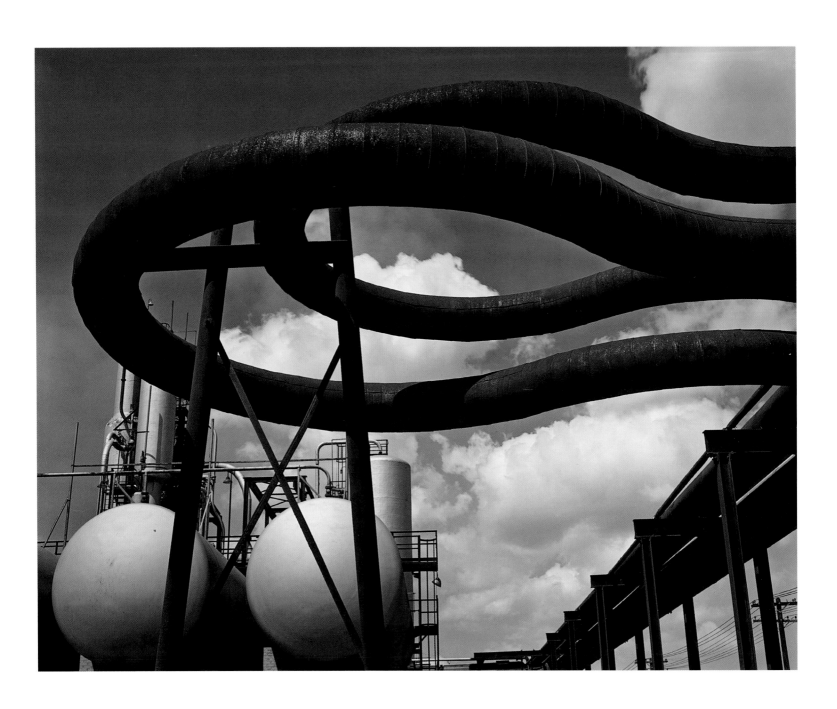

Gulf Oil, Port Arthur, Texas, 1941
Gelatin silver print
19.3 x 24.3 cm
Center for Creative Photography, University
of Arizona, Edward Weston Archive
Printed by Brett Weston, supervised

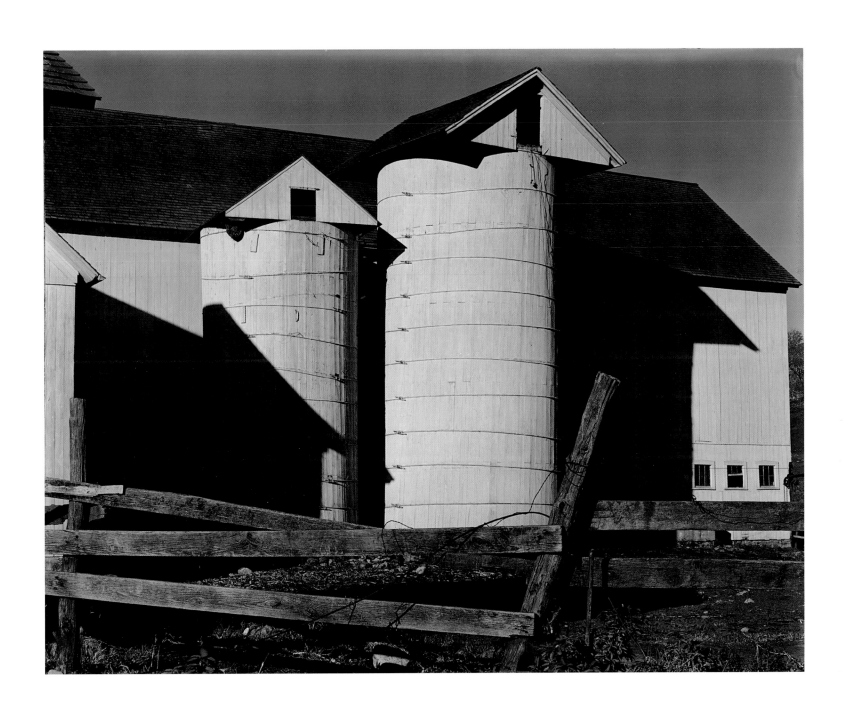

Connecticut Barn, 1941
Gelatin silver print
19.3 x 24.2 cm
Center for Creative Photography, University
of Arizona, Edward Weston Archive, Gift
of the Heirs of Edward Weston

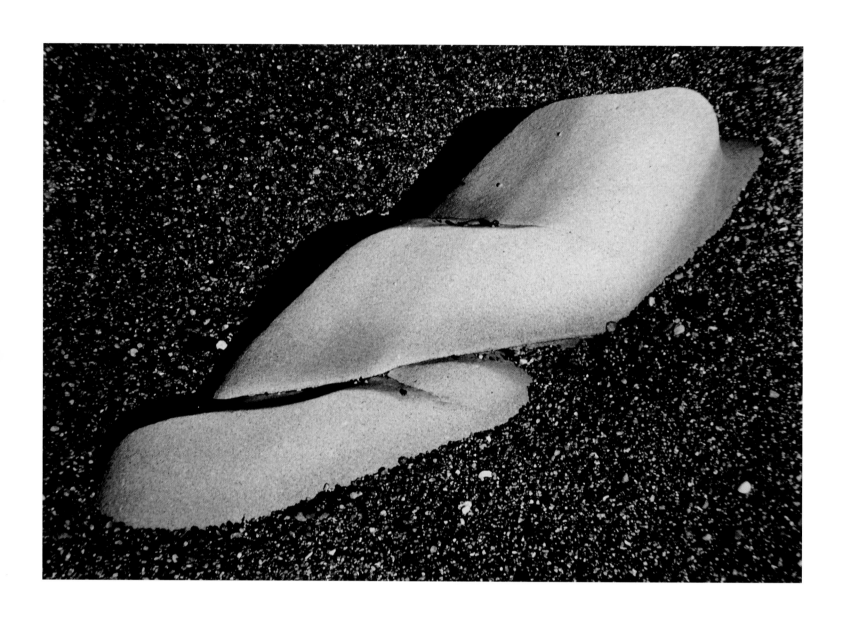

Eroded Rock, 1930
Gelatin silver print
16.5 x 24.1 cm
Margaret Weston Collection

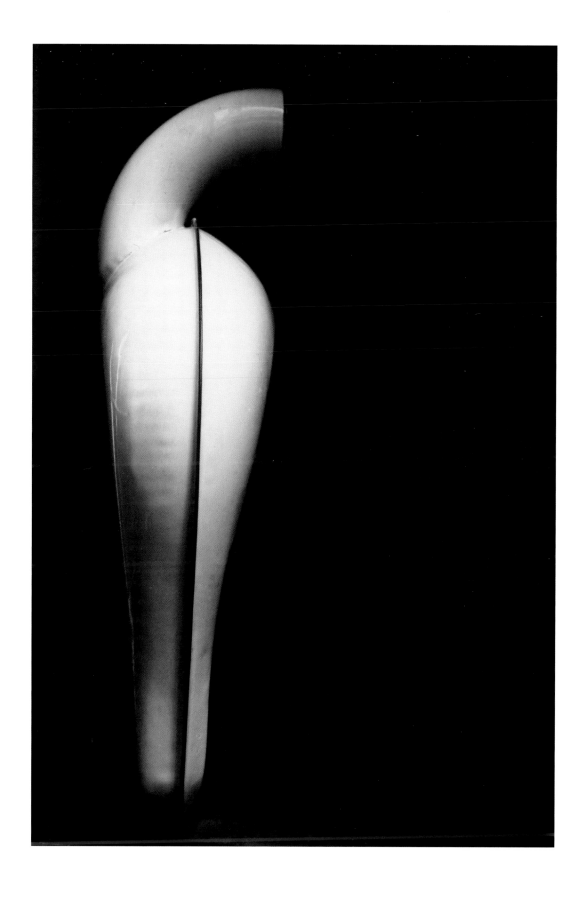

Bedpan, 1930
Gelatin silver print
23.5 x 16.5 cm
Margaret Weston Collection
Printed by Brett Weston

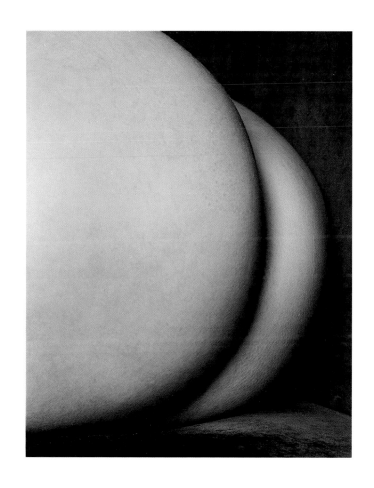

Nude, 1934
Gelatin silver print
11.3 x 9.3 cm
Center for Creative Photography, University
of Arizona, Edward Weston Archive

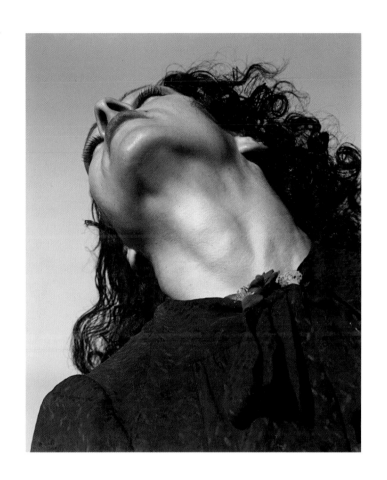

La Teresina, 1933
Gelatin silver print
11 x 9.2 cm
Center for Creative Photography, University
of Arizona, Sonya Noskowiak Collection,
Gift of Arthur Noskowiak

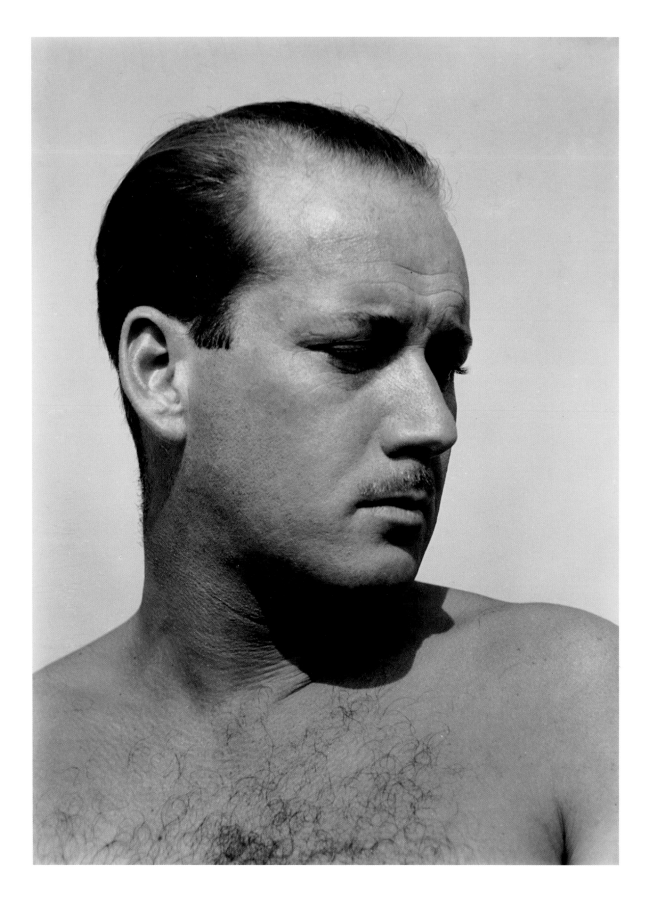

Mr. MacPherson, 1932
Gelatin silver print
24.9 x 18.4 cm
Center for Creative Photography, University
of Arizona, Edward Weston Archive

60

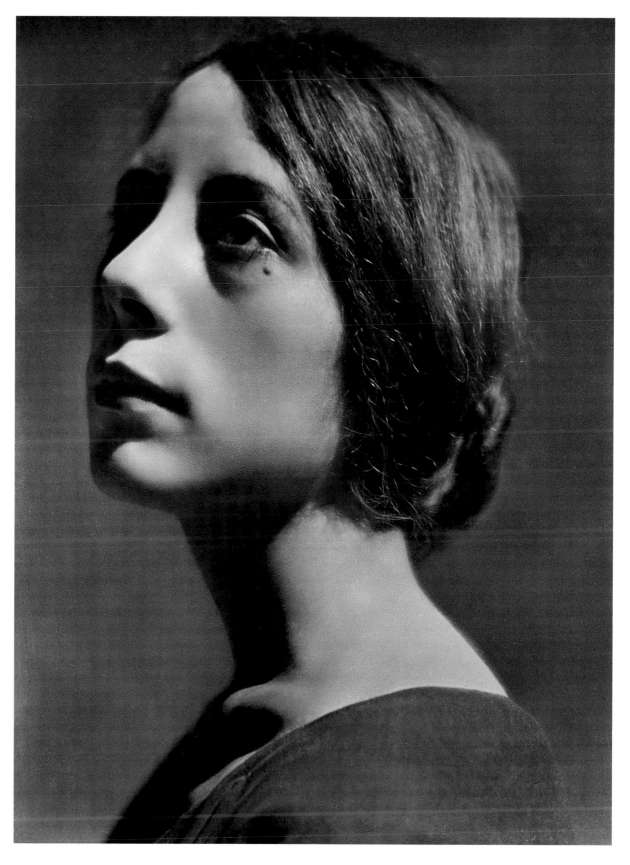

Monna de Sala, Mexico, 1924
Gelatin silver print
23.3 x 17.7 cm
Center for Creative Photography, University
of Arizona, Edward Weston Archive
Printed by Brett Weston, unsupervised

Arizona Nymph, 1938
Gelatin silver print
19 x 24.2 cm
Center for Creative Photography, University
of Arizona, Edward Weston Archive
Printed by Brett Weston, supervised

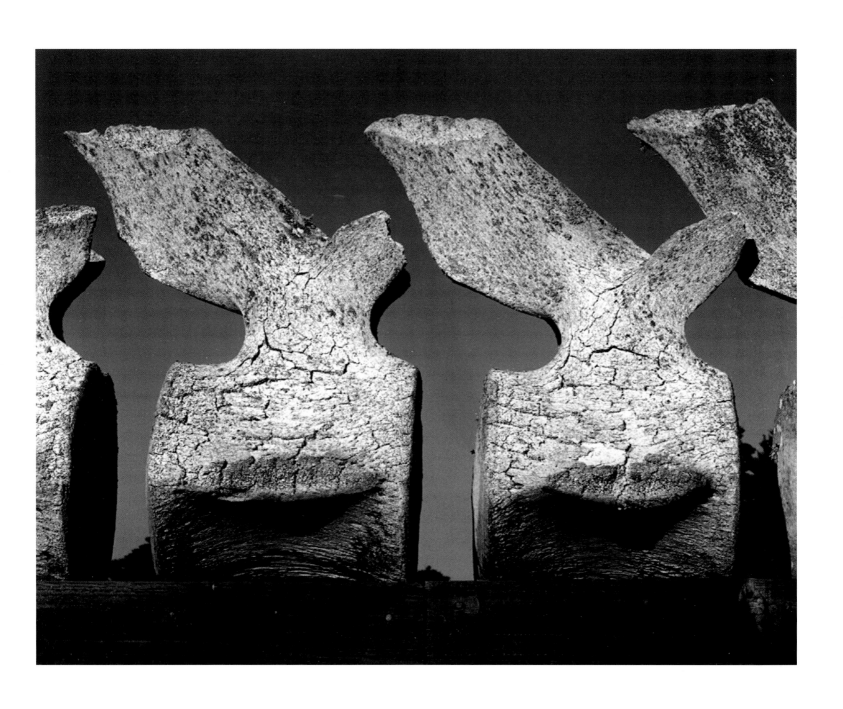

Whale Vertebrae, Point Lobos, 1934
Gelatin silver print
19.1 x 24.1 cm
Matthew and Davika Weston Collection

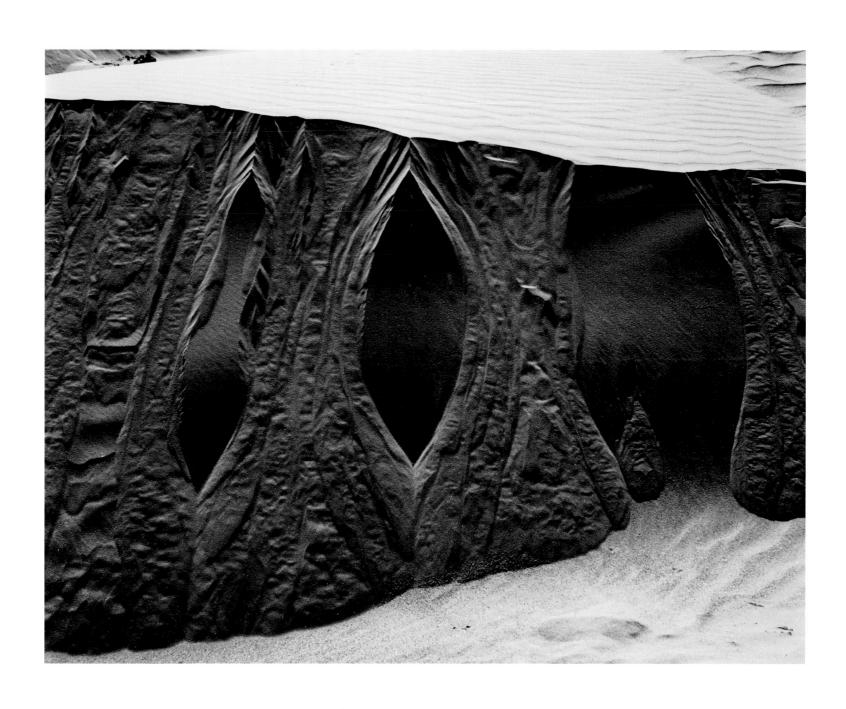

Dunes, Oceano, 1936
Gelatin silver print
19.2 x 24.5 cm
Center for Creative Photography, University
of Arizona, Sonya Noskowiak Collection,
Gift of Arthur Noskowiak

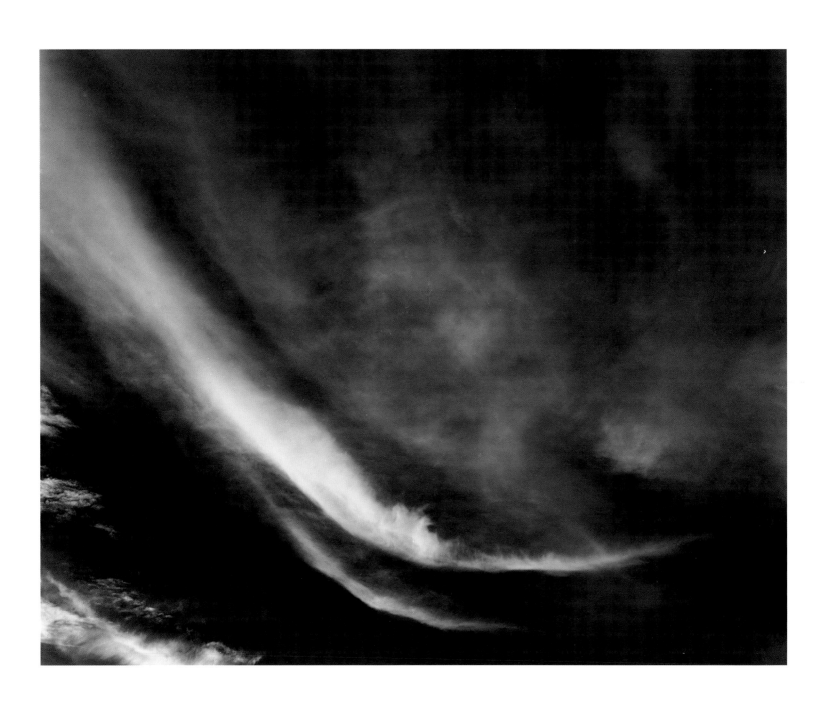

Cloud, 1936
Gelatin silver print
19.3 x 24.3 cm
Center for Creative Photography, University
of Arizona, Edward Weston Archive

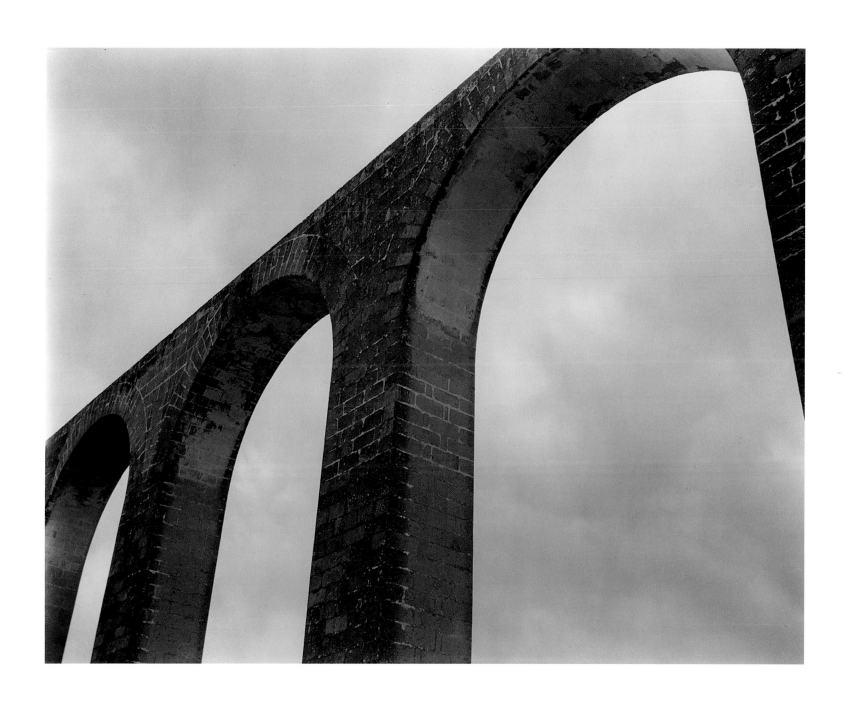

Aqueduct, Los Remedios, 1924
Gelatin silver print
19 x 24 cm
Center for Creative Photography, University
of Arizona, Edward Weston Archive
Printed by Brett Weston, unsupervised

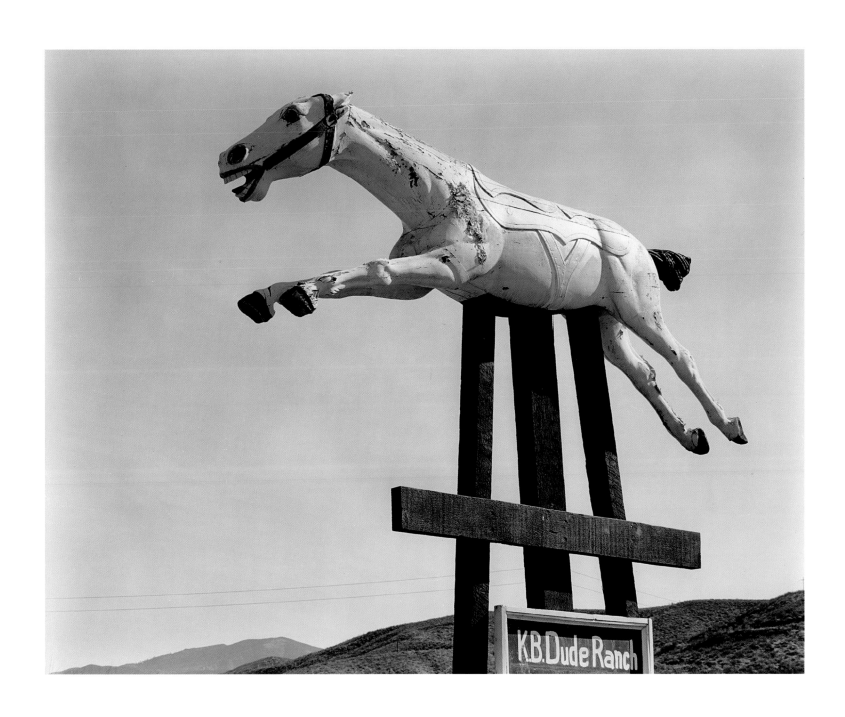

Horse, KB Dude Ranch, 1938
Gelatin silver print
19.1 x 24 cm
Center for Creative Photography, University
of Arizona, Edward Weston Archive
Printed by Brett Weston, supervised

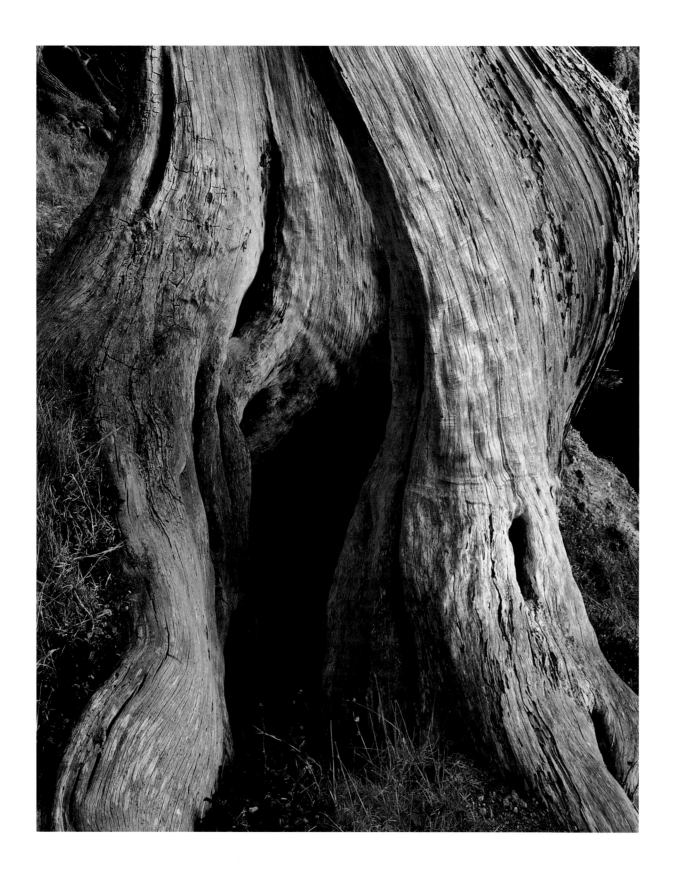

Cypress, Point Lobos, 1930
Gelatin silver print
24.1 x 19.1 cm
Center for Creative Photography, University
of Arizona, Edward Weston Archive

MGM Studios, 1939
Gelatin silver print
24.6 x 19.9 cm
Center for Creative Photography, University
of Arizona, Edward Weston Archive

Carmelita Maracci, 1937
Gelatin silver print
23.8 x 18.6 cm
Center for Creative Photography, University
of Arizona, Edward Weston Archive

Guadalupe Marín de Rivera, Mexico, 1924
Gelatin silver print
22.9 x 17.8 cm
Center for Creative Photography, University
of Arizona, Edward Weston Archive, Gift
of the Heirs of Edward Weston
Printed by Brett Weston, supervised

Tina Modotti, ca. 1924
Gelatin silver print
4.6 x 6.5 cm
Center for Creative Photography, University
of Arizona, Edward Weston Archive

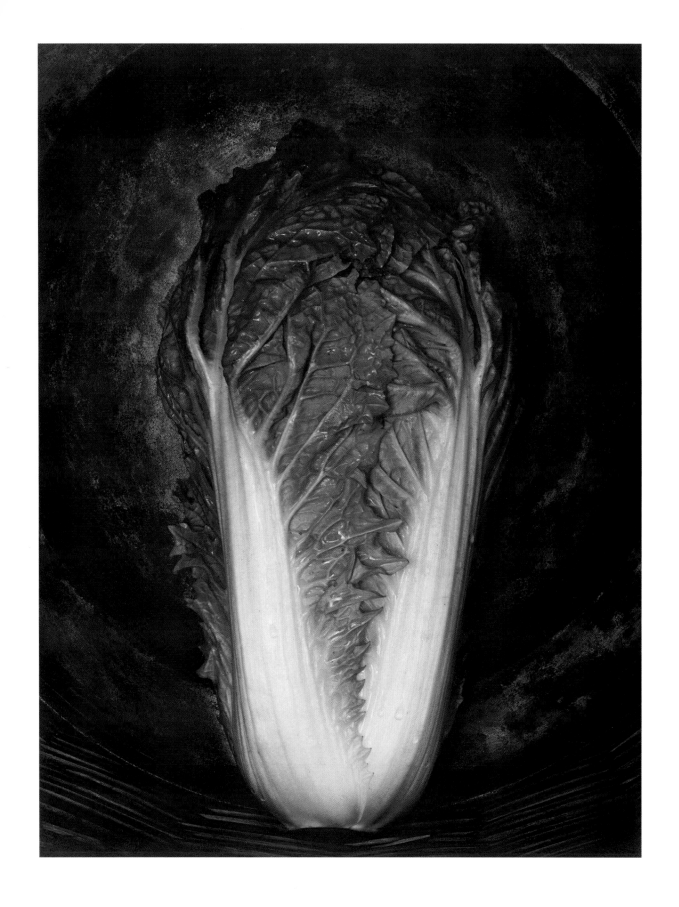

Chard, 1928
Gelatin silver print
24 x 18.7 cm
Center for Creative Photography, University
of Arizona, Johan Hagemeyer Collection

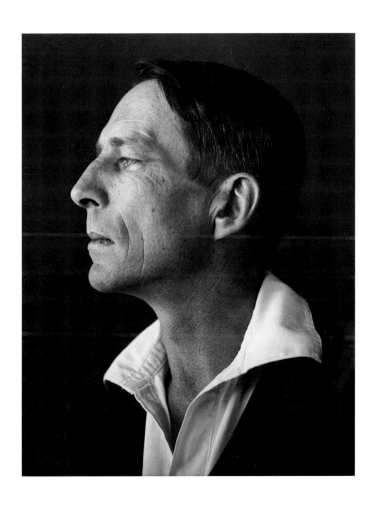

Robinson Jeffers, 1933
Gelatin silver print
11.7 x 9.1 cm
Center for Creative Photography, University
of Arizona, Sonya Noskowiak Collection,
Gift of Arthur Noskowiak

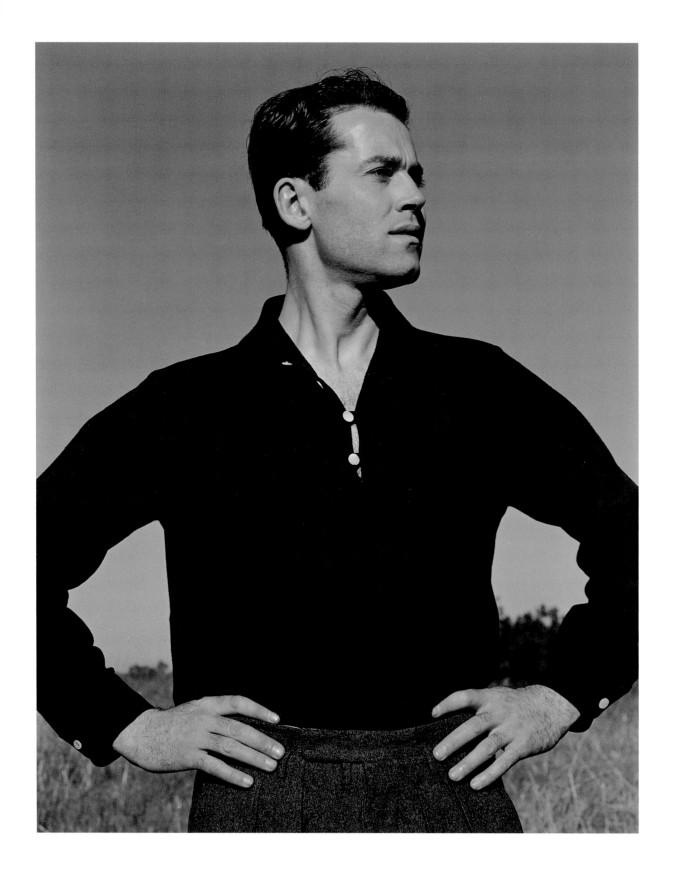

Henry Fonda, 1936
Gelatin silver print
24.3 x 19.3 cm
Center for Creative Photography, University
of Arizona, Edward Weston Archive

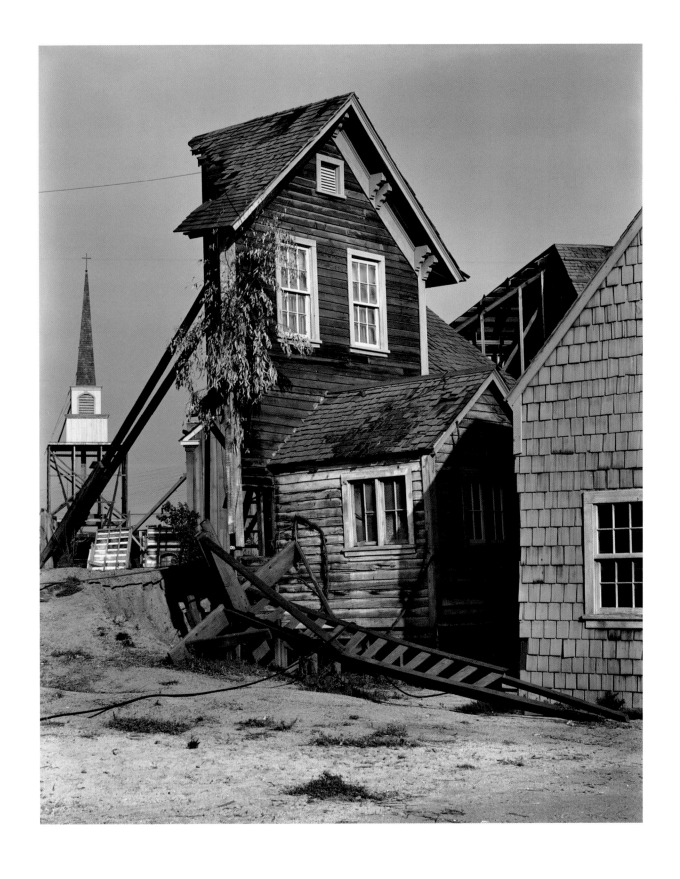

Movie Set, 1940
Gelatin silver print
24.3 x 19.3 cm
Center for Creative Photography, University
of Arizona, Edward Weston Archive

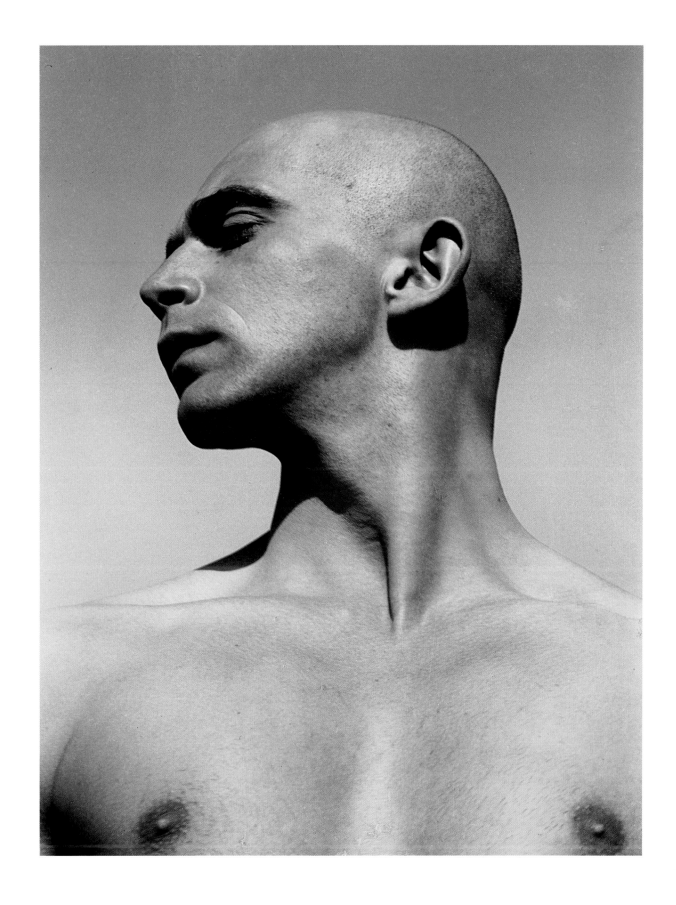

Harald Kreutzberg, 1932
Gelatin silver print
24.1 x 19 cm
Center for Creative Photography, University
of Arizona, Edward Weston Archive

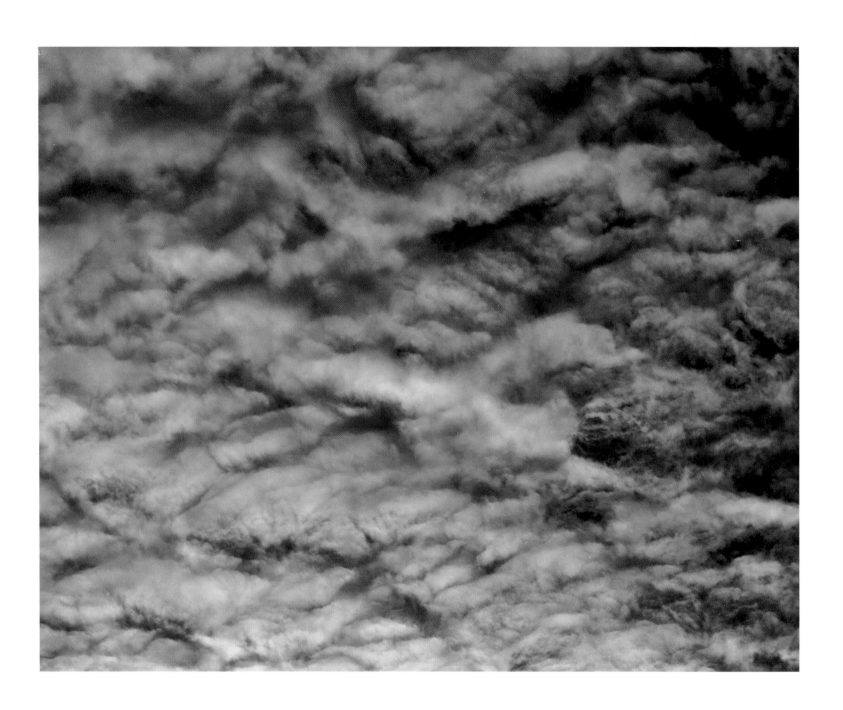

Clouds, 1936
Gelatin silver print
19.3 x 24.2 cm
Center for Creative Photography, University
of Arizona, Edward Weston Archive

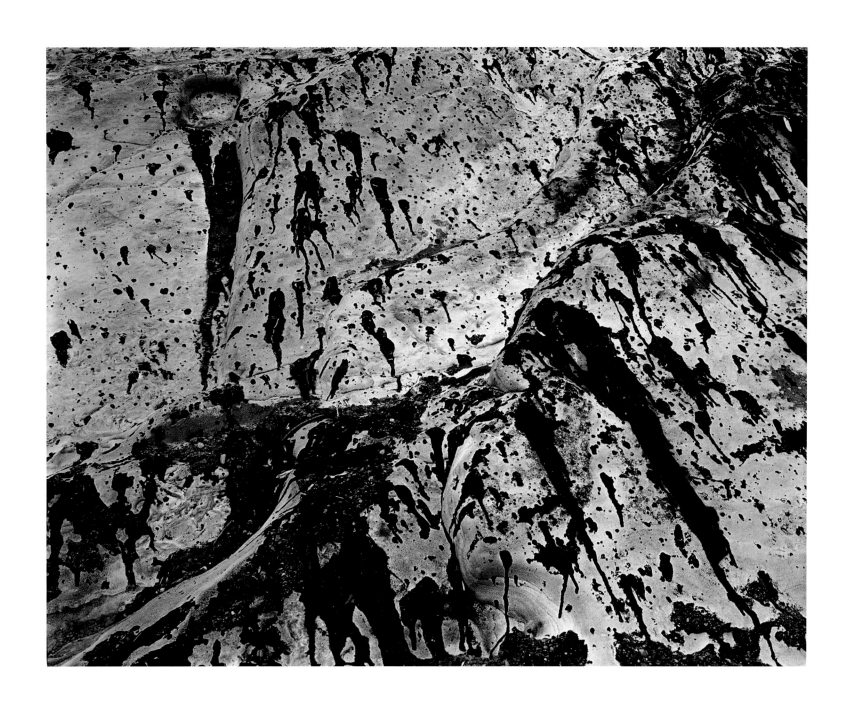

Tar Drippings, Point Lobos, 1942
Gelatin silver print
19.3 x 24.4 cm
Center for Creative Photography, University
of Arizona, Edward Weston Archive

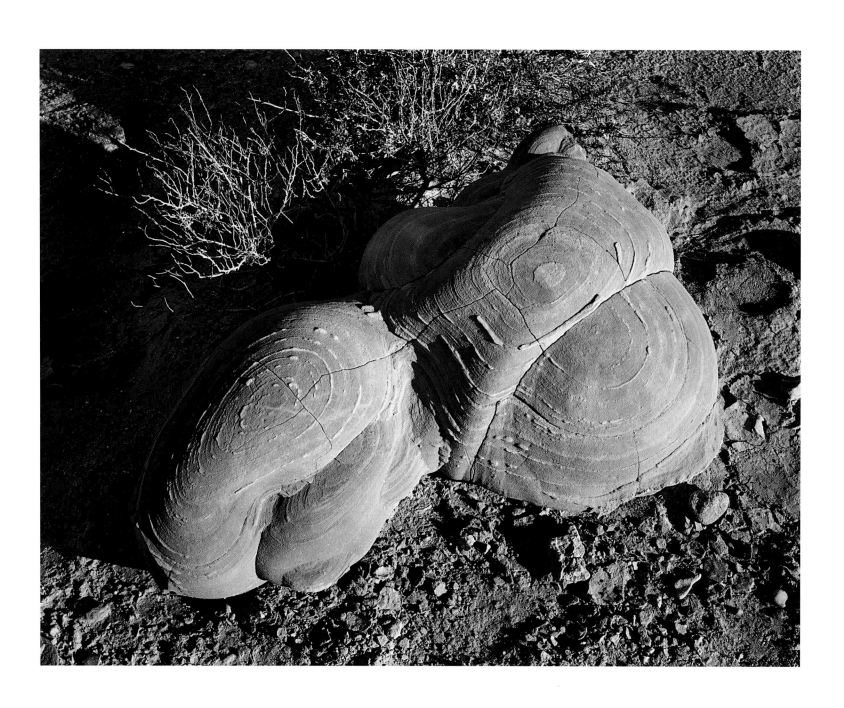

Concretion, Salton Sea, 1938
Gelatin silver print
19 x 24 cm
Center for Creative Photography, University
of Arizona, Edward Weston Archive

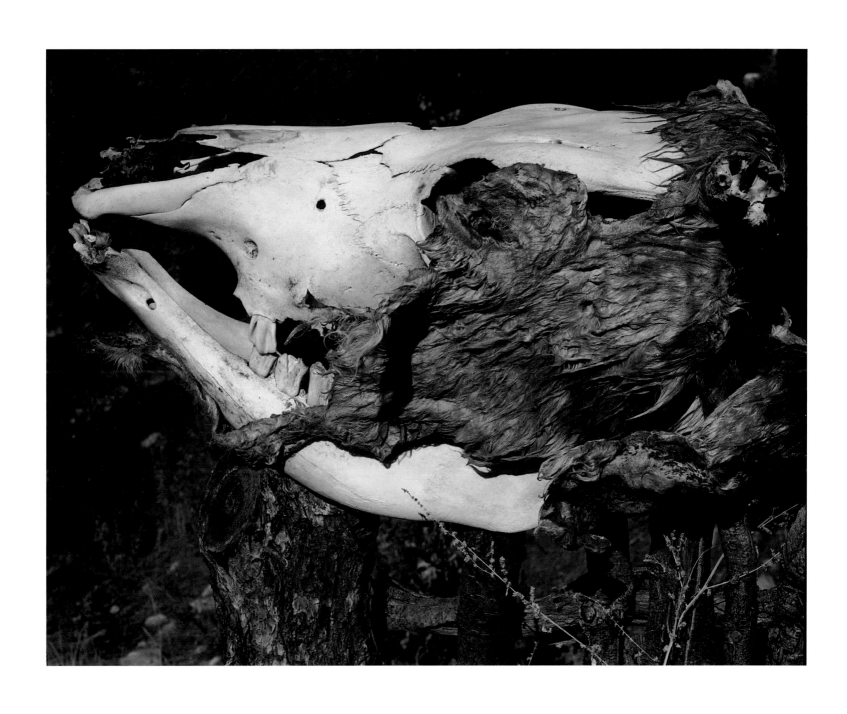

Skull, Arizona, 1938
Gelatin silver print
19 x 24.2 cm
Center for Creative Photography, University
of Arizona, Edward Weston Archive

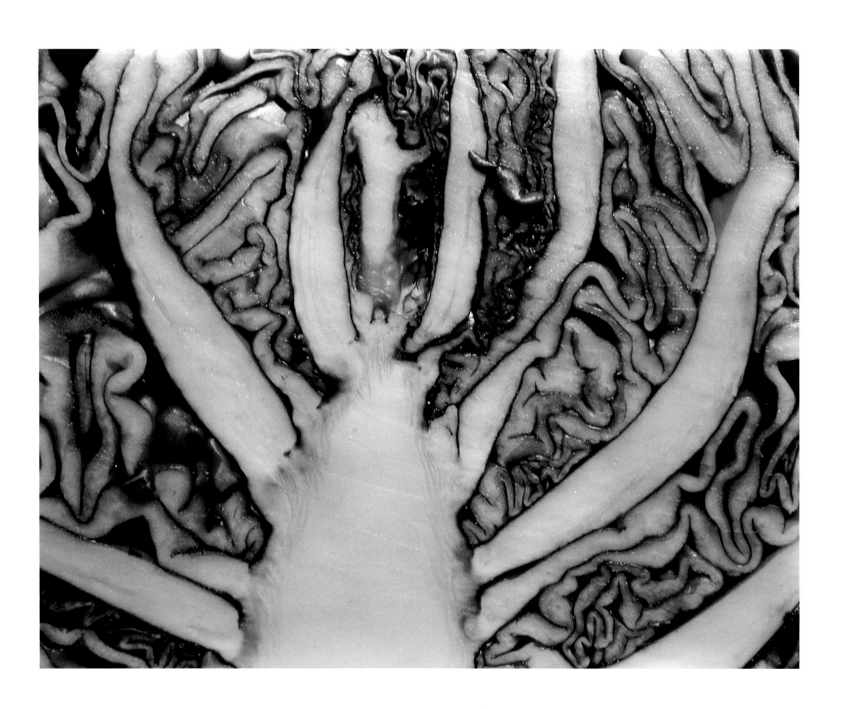

Red Cabbage Halved, 1930
Gelatin silver print
19.1 x 24.1 cm
Margaret Weston Collection

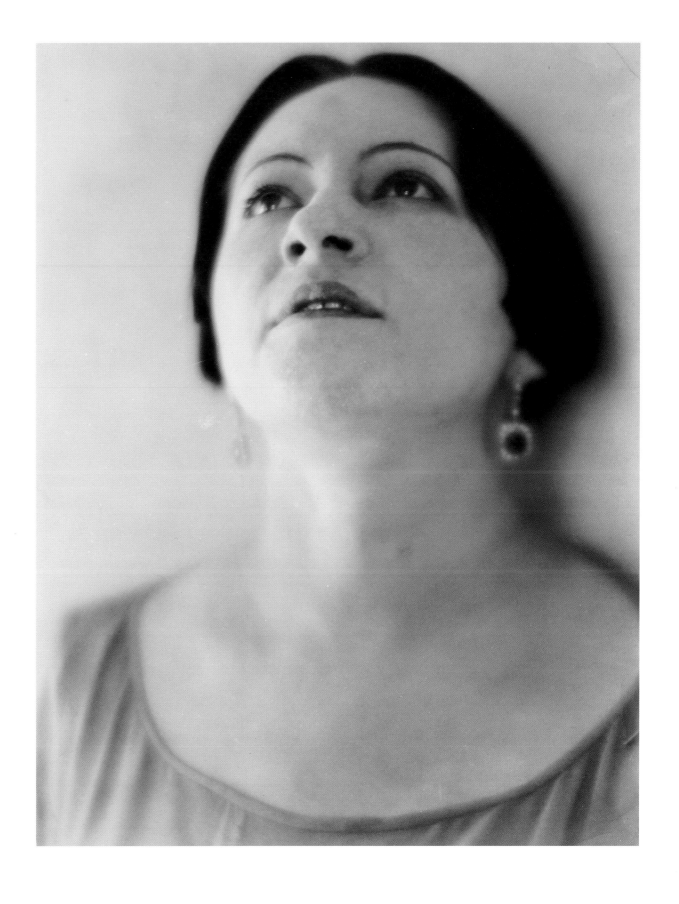

Esperanza Velázquez Bringas, 1924
Gelatin silver print
23.3 x 19.1 cm
Center for Creative Photography,
University of Arizona

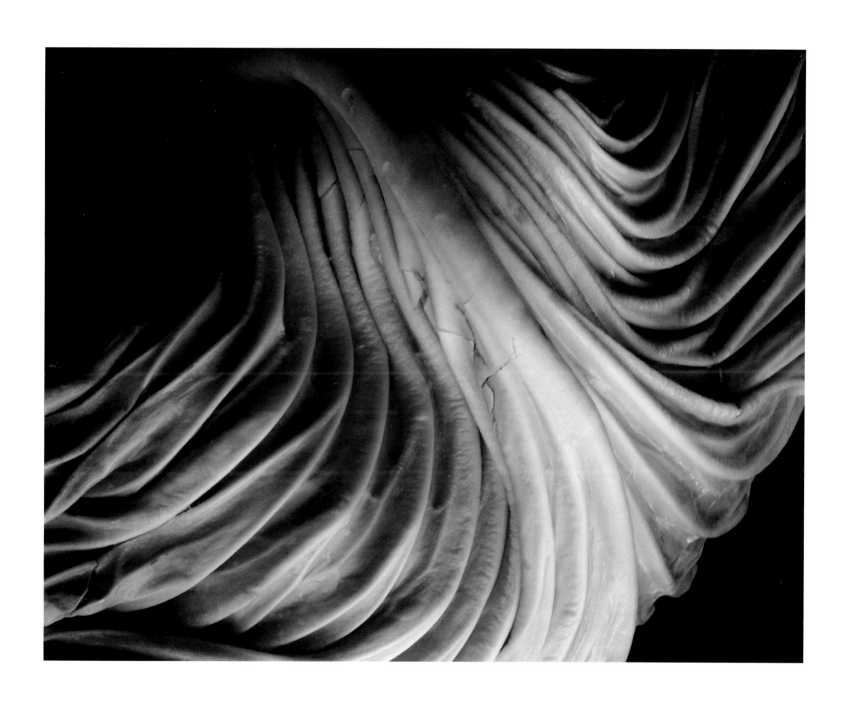

Cabbage Leaf, 1931
Gelatin silver print
19.1 x 24.1 cm
Center for Creative Photography, University
of Arizona, Edward Weston Archive

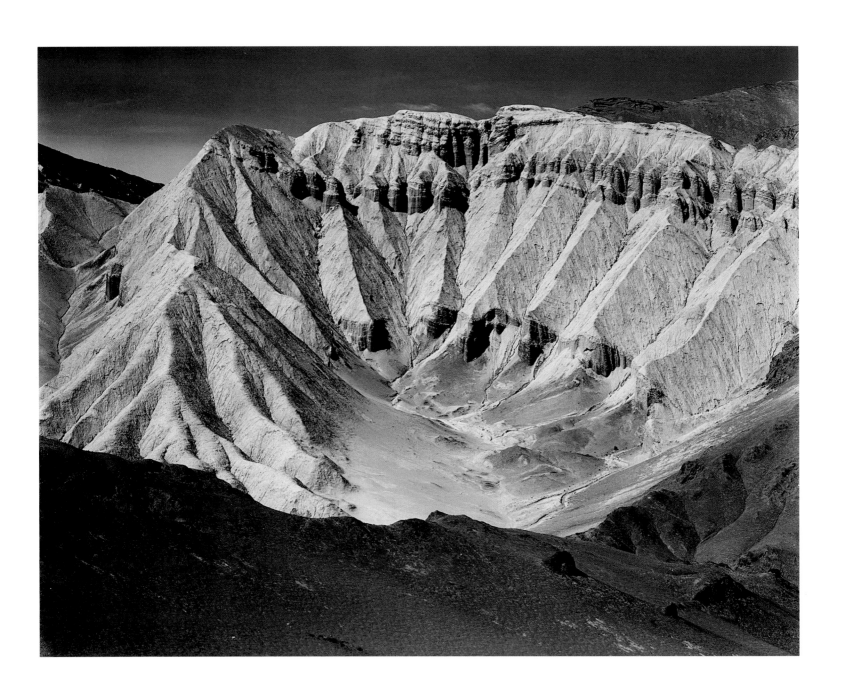

Twenty Mule Team Canyon, 1938
Gelatin silver print
18.8 x 24 cm
Center for Creative Photography, University
of Arizona, Edward Weston Archive, Gift
of the Heirs of Edward Weston
Printed by Brett Weston, supervised

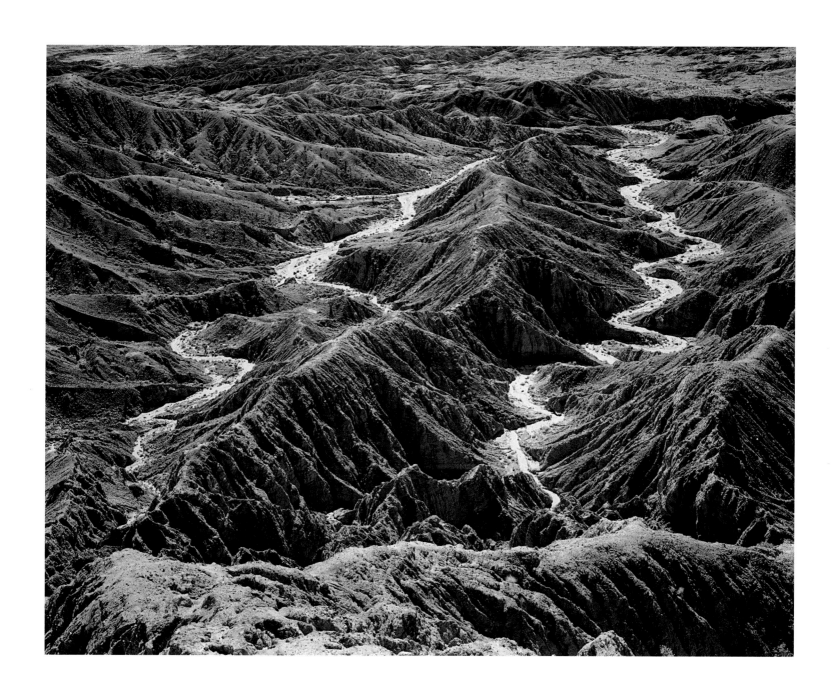

*Badlands, Borrego Desert (view down at dark
eroded slopes, two pale winding washes)*, 1938
Gelatin silver print
18.8 x 24 cm
Center for Creative Photography, University
of Arizona, Edward Weston Archive

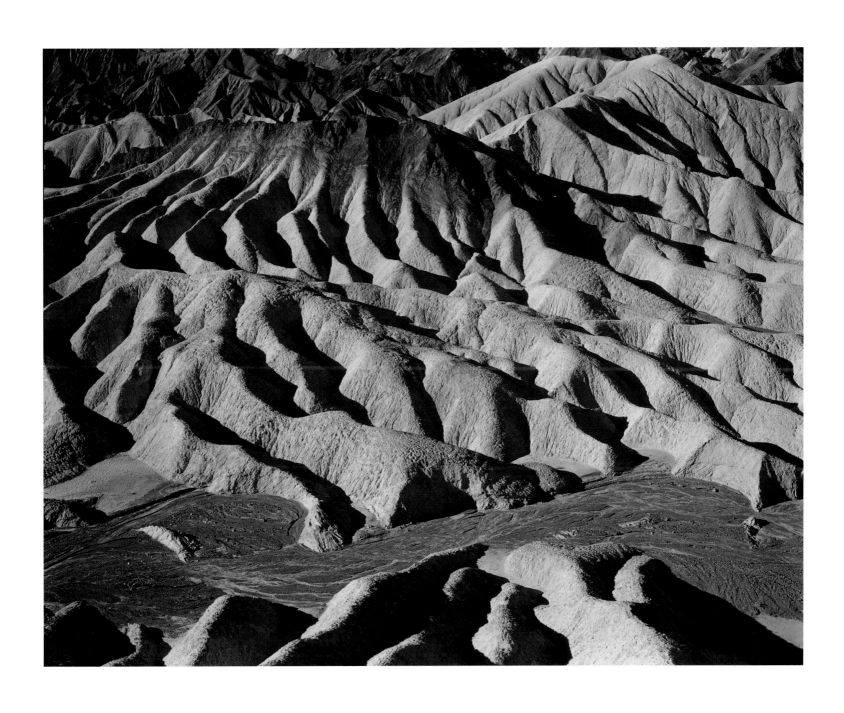

Zabriskie Point, Death Valley, 1938
Gelatin silver print
19 x 24.2 cm
Center for Creative Photography, University
of Arizona, Edward Weston Archive

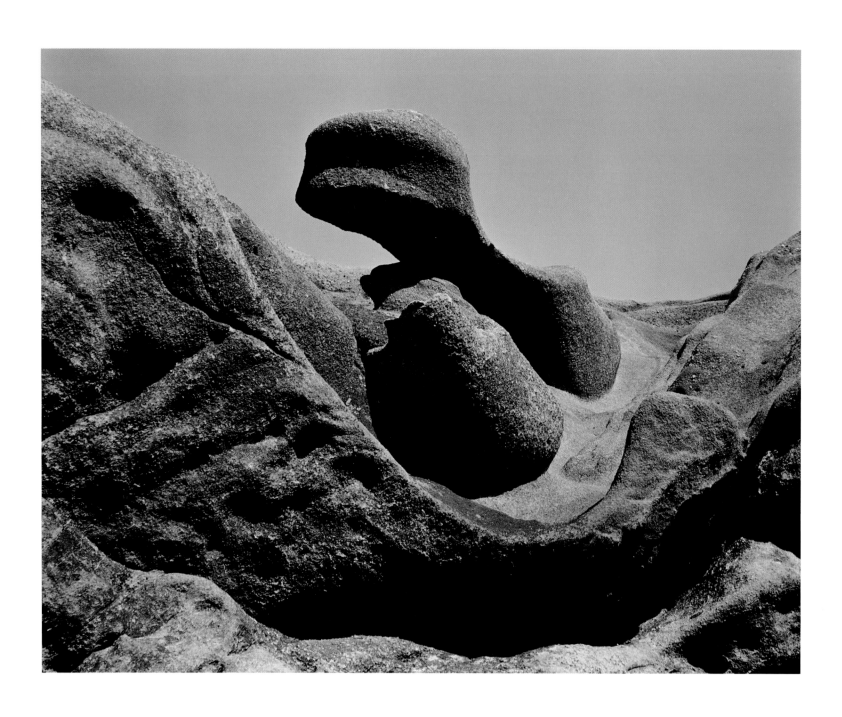

Point Lobos, 1932
Gelatin silver print
19 x 23.9 cm
Center for Creative Photography, University
of Arizona, Edward Weston Archive
Printed by Brett Weston, supervised

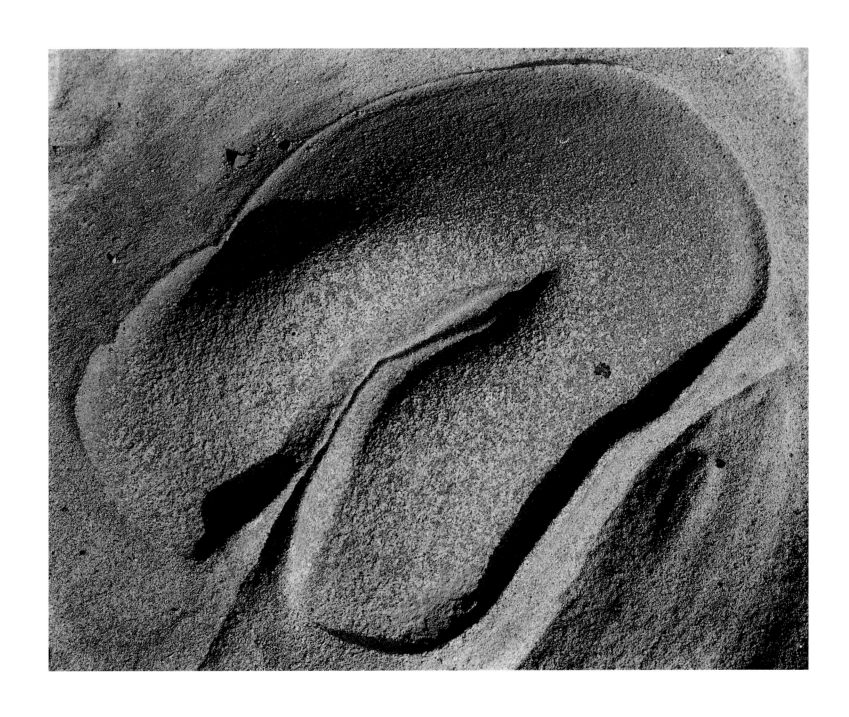

Point Lobos, 1929
Gelatin silver print
19.1 x 24.1 cm
Center for Creative Photography, University
of Arizona, Edward Weston Archive

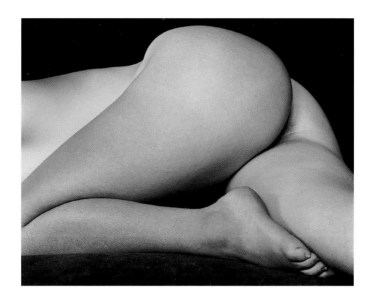

Nude, 1934
Gelatin silver print
9.1 x 11.7 cm
Center for Creative Photography, University
of Arizona, Edward Weston Archive
Printed by Cole Weston, supervised

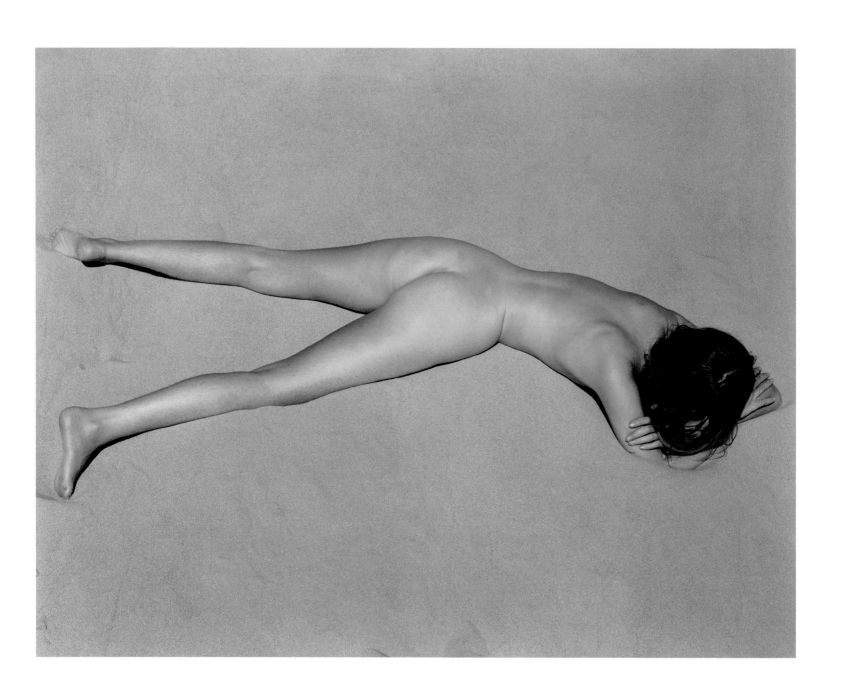

Nude, 1936
Gelatin silver print
19.1 x 24 cm
Center for Creative Photography, University
of Arizona, Edward Weston Archive, Gift
of the Heirs of Edward Weston
Printed by Brett Weston, supervised

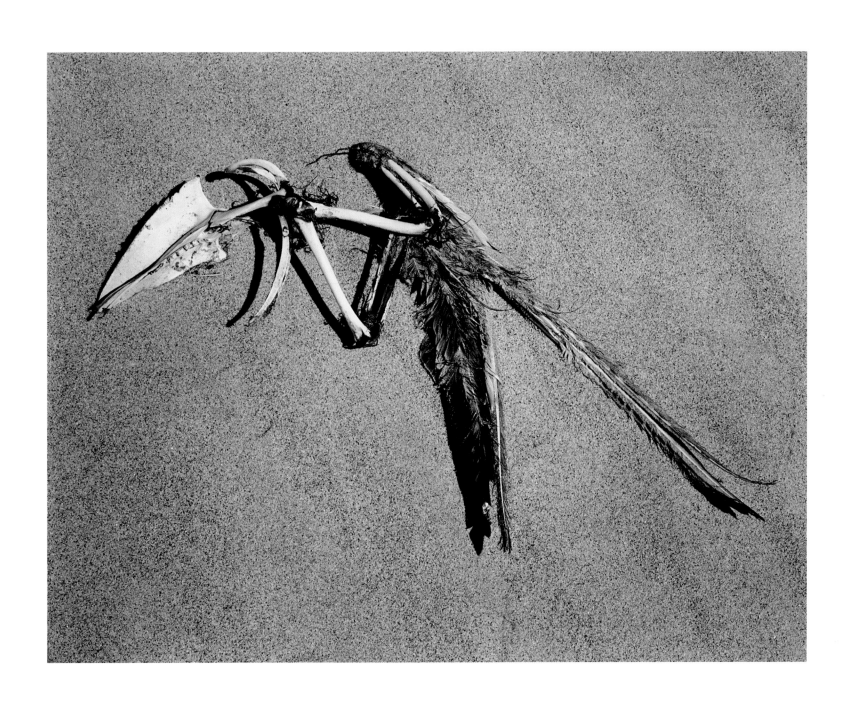

Bird Skeleton, Oceano, 1936
Gelatin silver print
19.3 x 24.3 cm
Center for Creative Photography, University
of Arizona, Edward Weston Archive

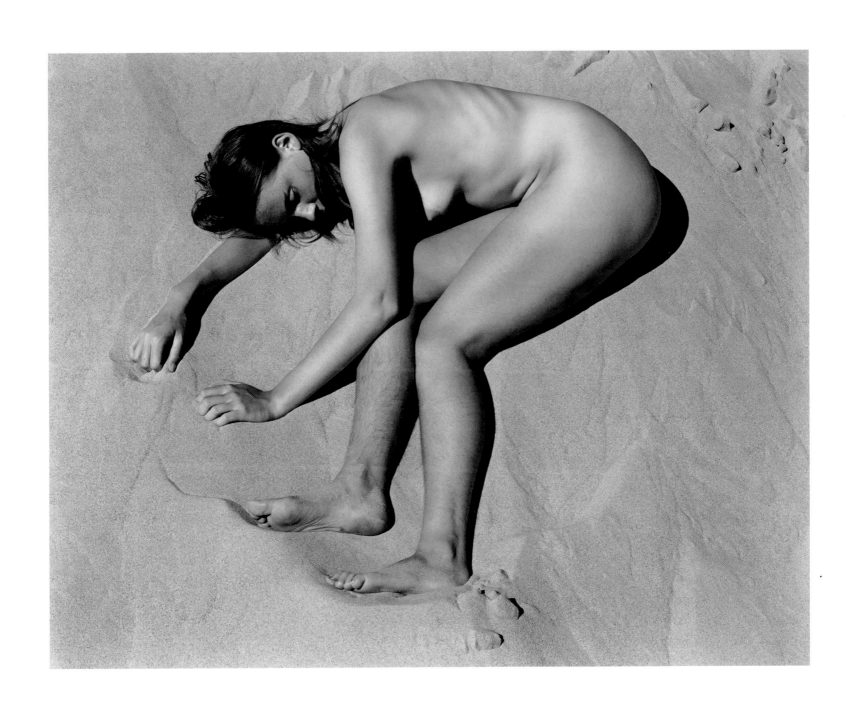

Nude, 1936
Gelatin silver print
19.1 x 24.2 cm
Center for Creative Photography, University
of Arizona, Edward Weston Archive, Gift
of the Heirs of Edward Weston
Printed by Brett Weston, supervised

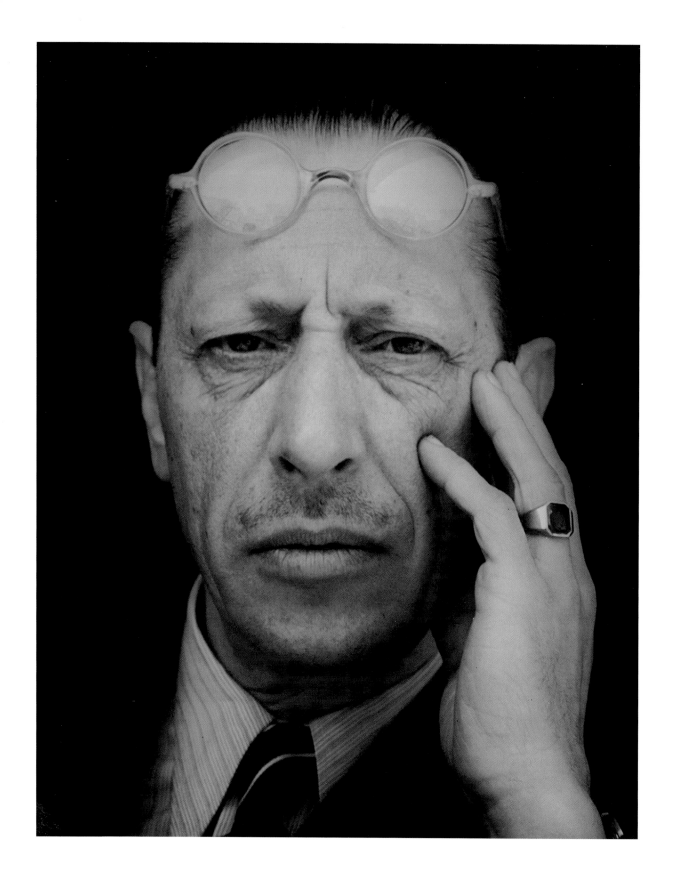

Igor Stravinsky, 1935
Gelatin silver print
23.9 x 19 cm
Center for Creative Photography, University
of Arizona, Edward Weston Archive

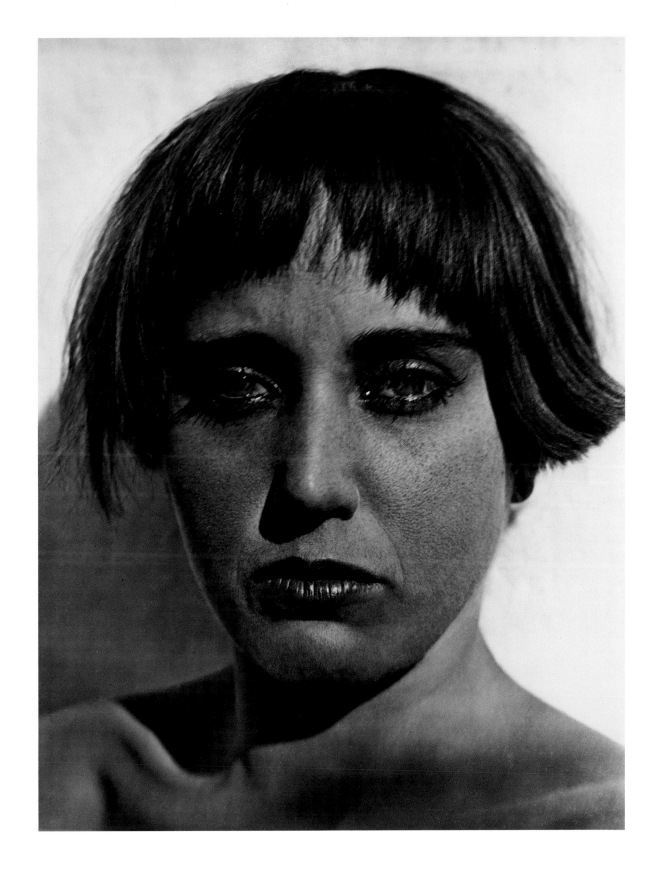

Nahui Olín, 1924
Gelatin silver print
23 x 17.4 cm
Center for Creative Photography, University
of Arizona, Edward Weston Archive, Gift
of the Heirs of Edward Weston
Printed by Brett Weston, supervised

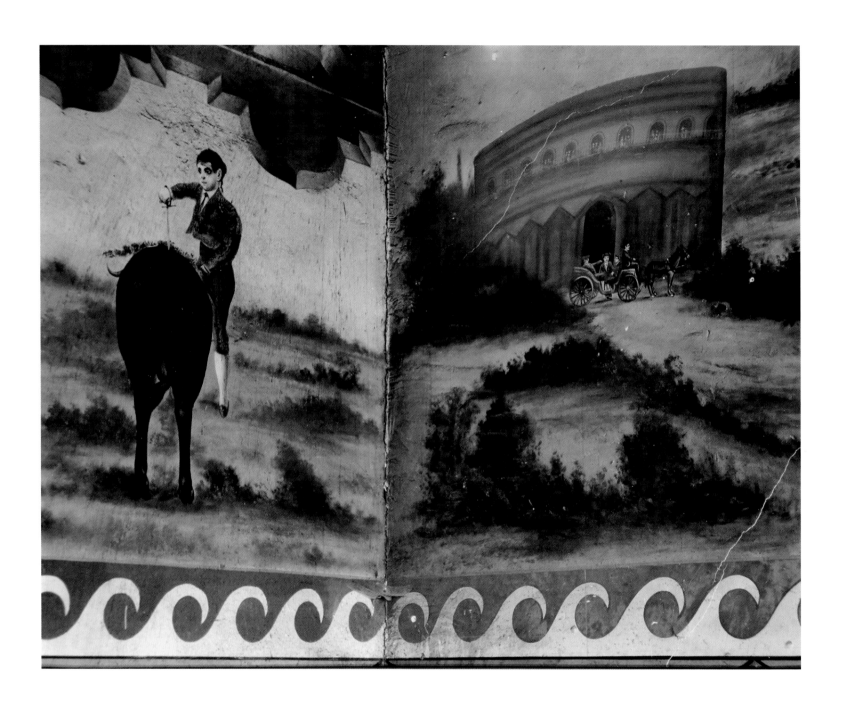

Pulqueria Mural, 1926
Gelatin silver print
19.1 x 24.1 cm
Margaret Weston Collection

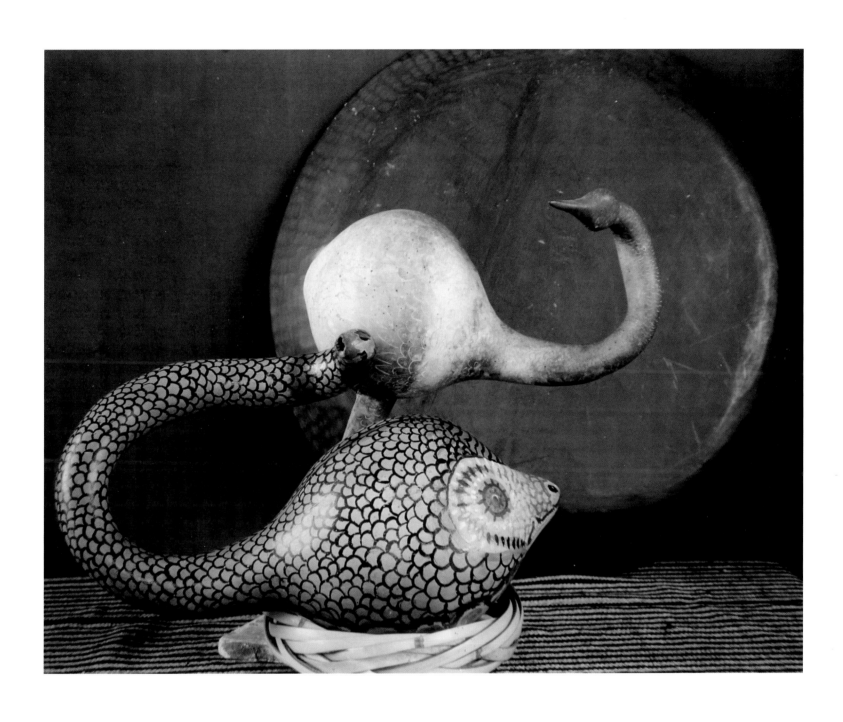

Fish and Bird Gourds, 1926
Gelatin silver print
19.1 x 24.1 cm
Margaret Weston Collection

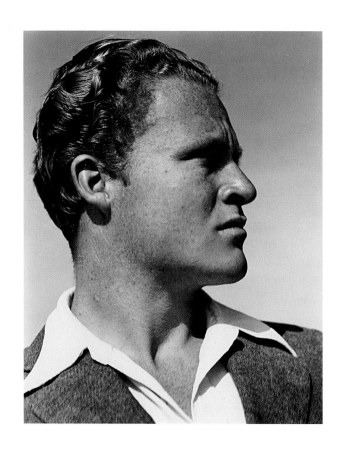

Brett Weston, 1931
Gelatin silver print
10.4 x 8.4 cm
Center for Creative Photography, University
of Arizona, Edward Weston Archive

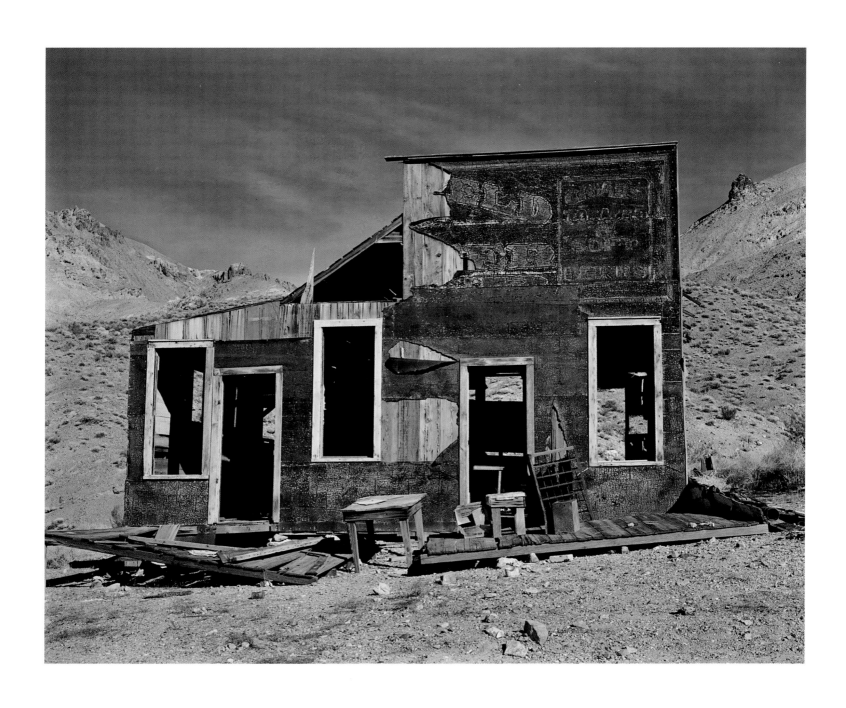

Leadfield, Death Valley, 1939
Gelatin silver print
19.1 x 24.1 cm
Center for Creative Photography, University
of Arizona, Edward Weston Archive, Gift
of the Heirs of Edward Weston

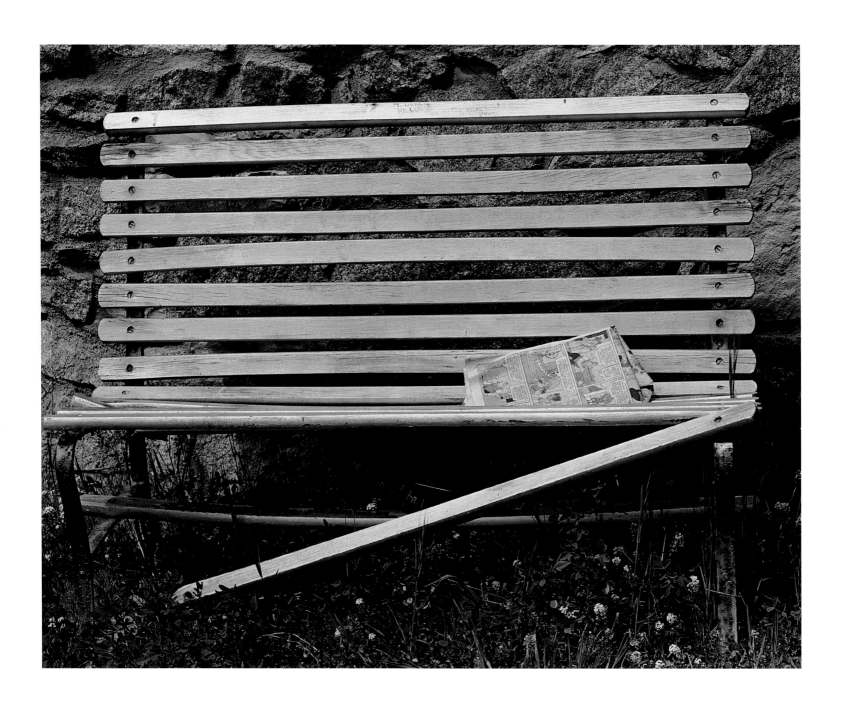

Bench, 1944
Gelatin silver print
19.3 x 24.4 cm
Center for Creative Photography, University
of Arizona, Edward Weston Archive

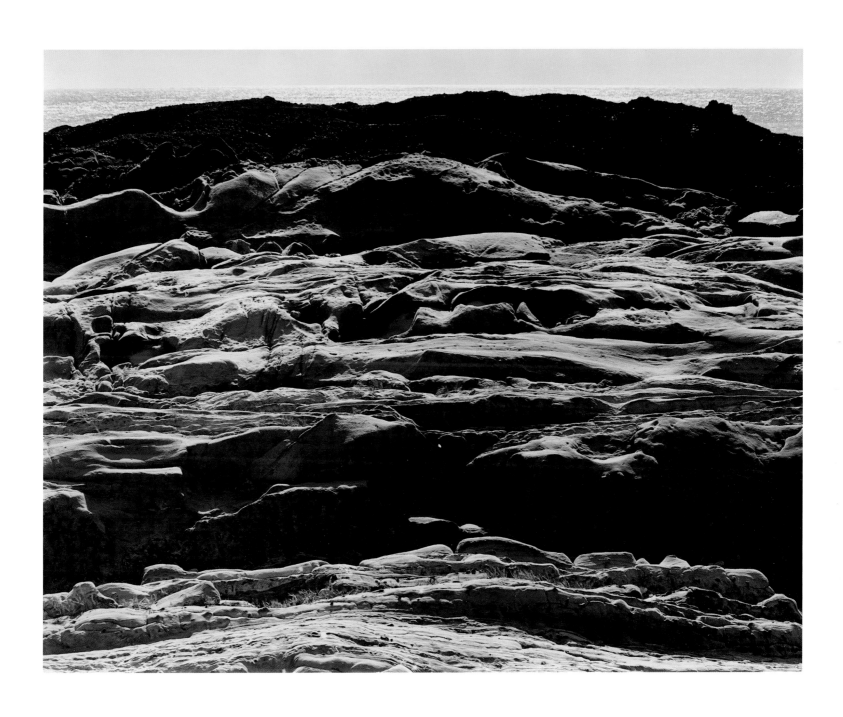

Rock Erosion, South Shore, Point Lobos, 1938
Gelatin silver print
19.2 x 24.2 cm
Center for Creative Photography, University
of Arizona, Gift of Ansel and Virginia Adams

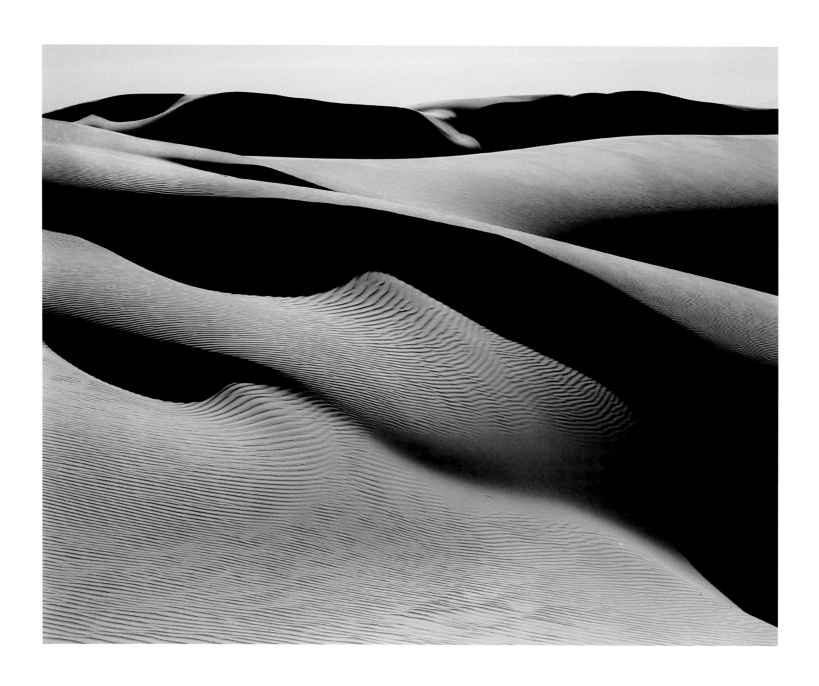

Dunes, Oceano, 1936
Gelatin silver print
19.2 x 24.2 cm
Center for Creative Photography, University
of Arizona, Edward Weston Archive

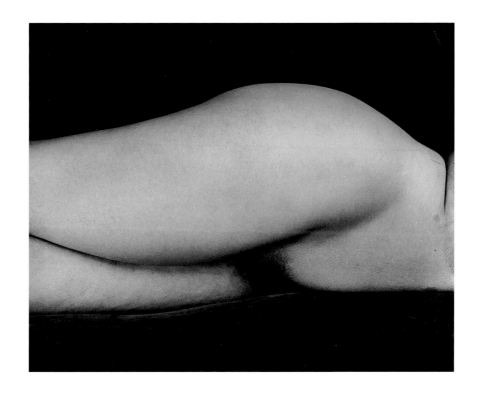

Nude, 1933
Gelatin silver print
9.3 x 11.8 cm
Center for Creative Photography, University
of Arizona, Edward Weston Archive

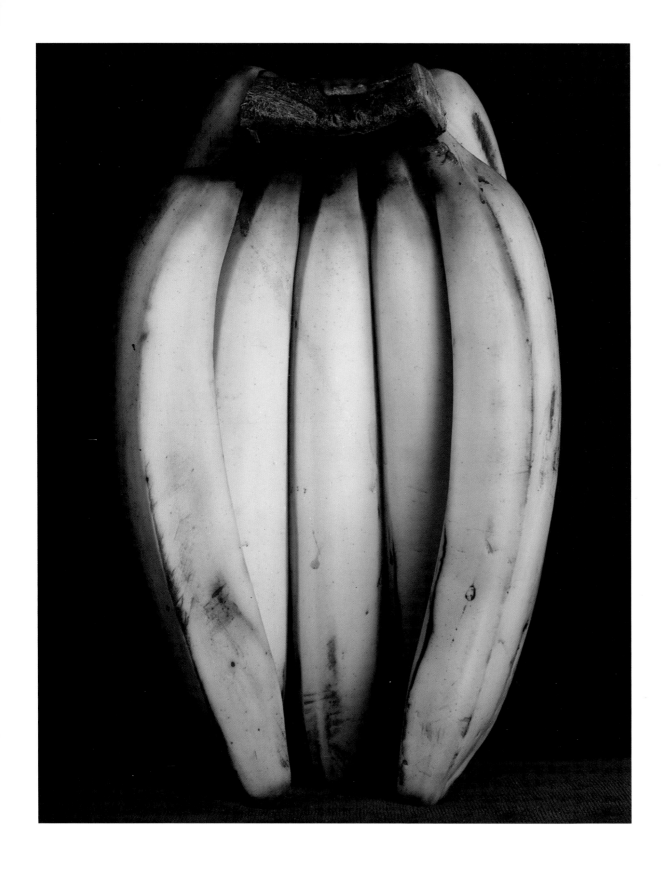

Bananas, 1930
Gelatin silver print
24 x 18.9 cm
Center for Creative Photography, University
of Arizona, Edward Weston Archive
Printed by Cole Weston, supervised

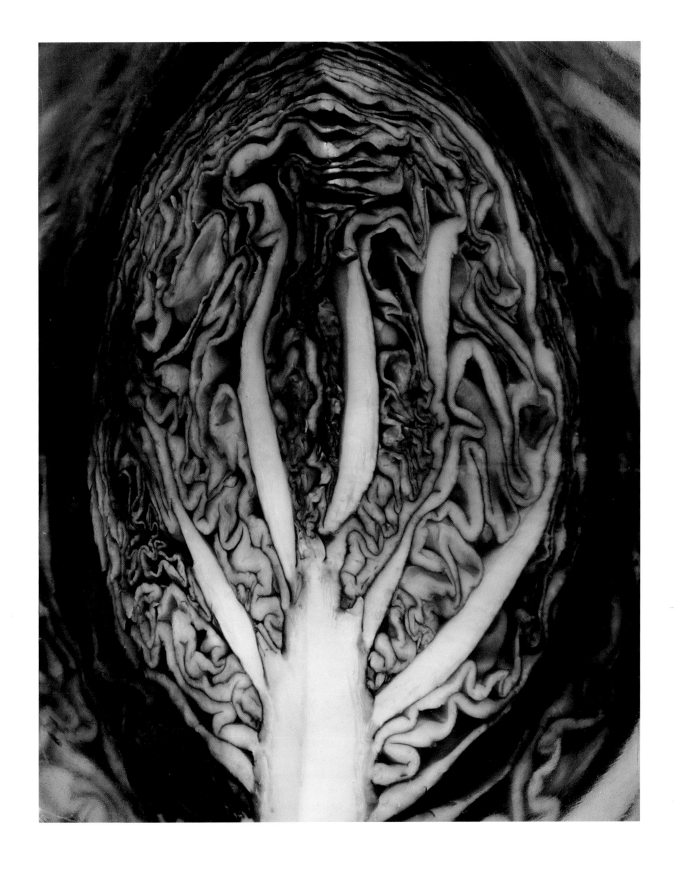

Red Cabbage Quartered, 1930
Gelatin silver print
24.1 x 19.1 cm
Center for Creative Photography, University
of Arizona, Edward Weston Archive

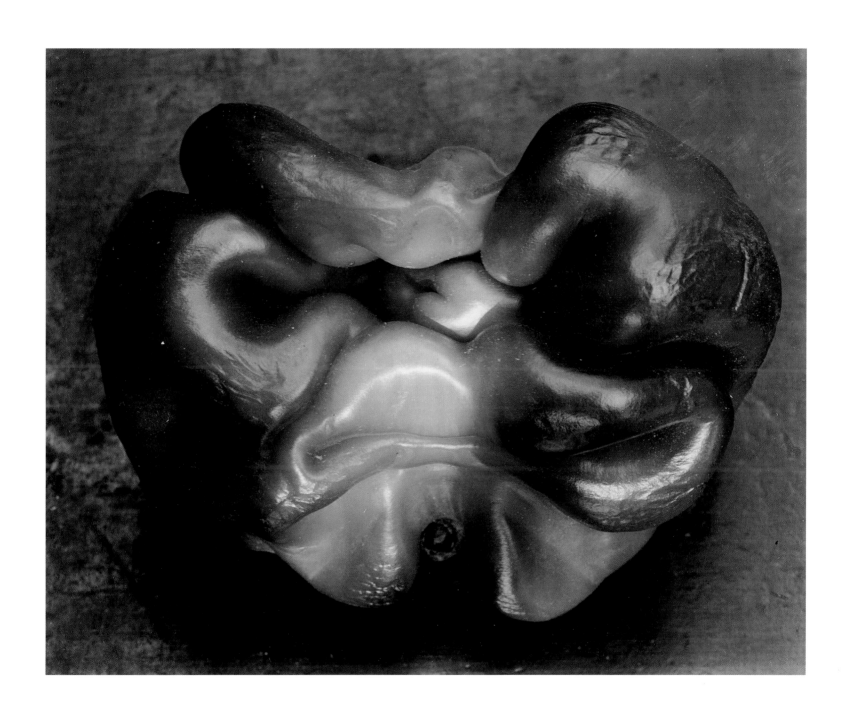

Pepper, 1930
Gelatin silver print
19.1 x 24 cm
Center for Creative Photography, University
of Arizona, Edward Weston Archive
Printed by Brett Weston, supervised

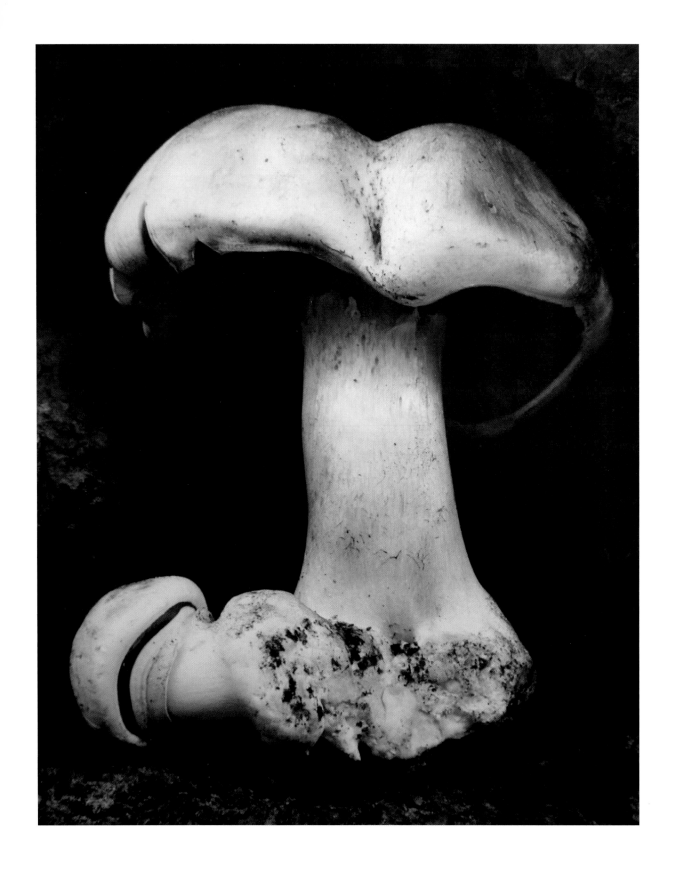

Toadstool, 1931
Gelatin silver print
23.5 x 19.1 cm
Margaret Weston Collection

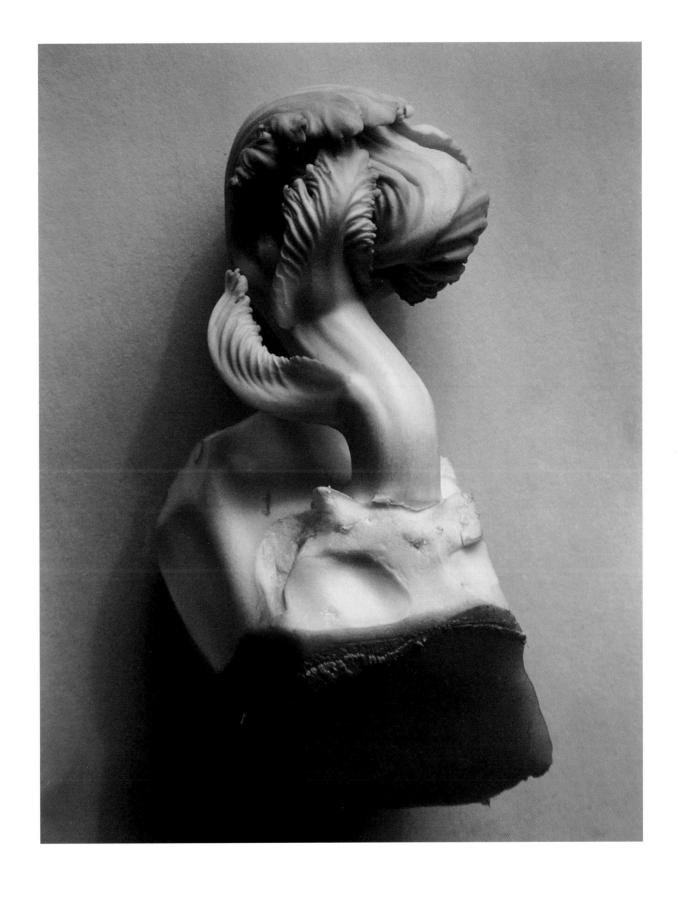

Cabbage Sprout, 1930
Gelatin silver print
24.1 x 19.1 cm
Margaret Weston Collection

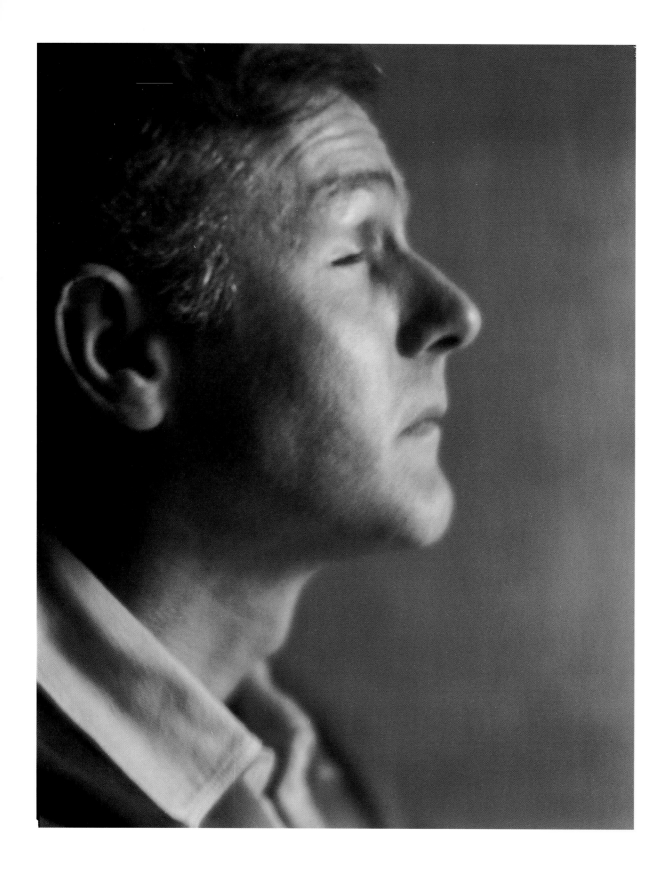

Blind, 1920
Gelatin silver print
24.3 x 19 cm
Center for Creative Photography, University
of Arizona, Edward Weston Archive

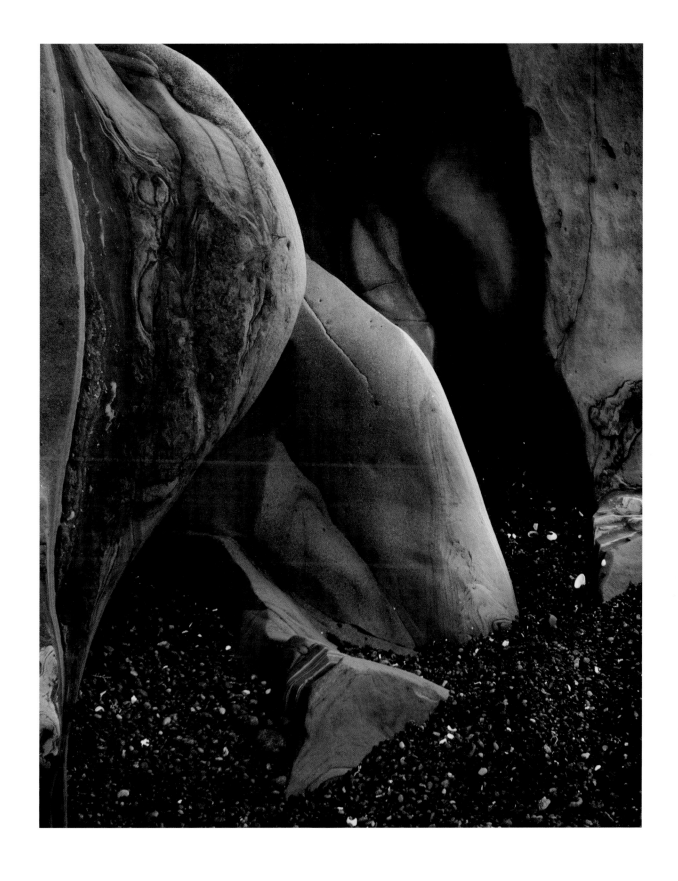

Eroded Rock, Point Lobos, 1930
Gelatin silver print
24 x 19.2 cm
Center for Creative Photography, University
of Arizona, Edward Weston Archive

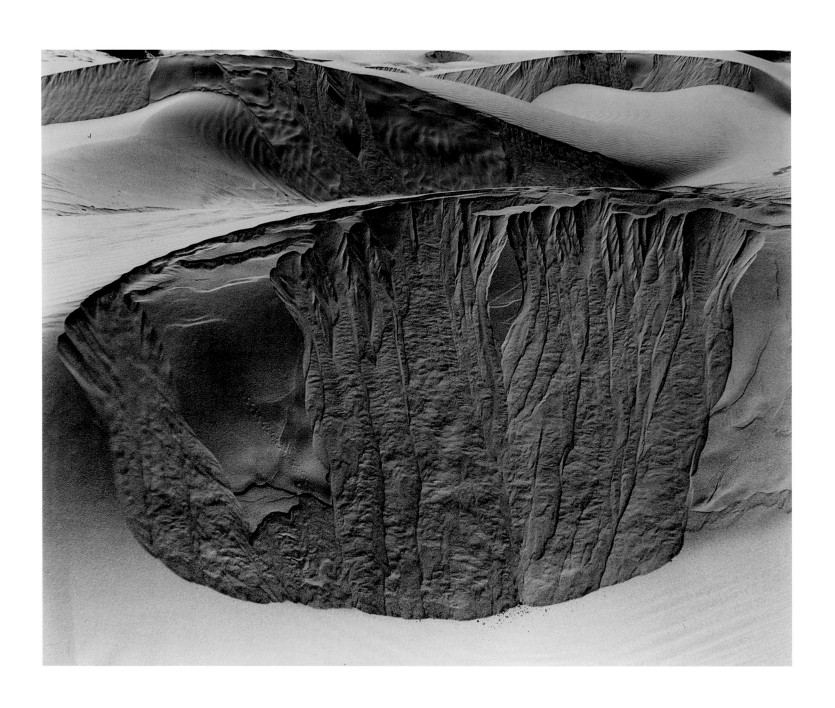

Dunes, Oceano, 1936
Gelatin silver print
19.2 x 24.2 cm
Center for Creative Photography, University
of Arizona, Edward Weston Archive
Printed by Brett Weston, supervised

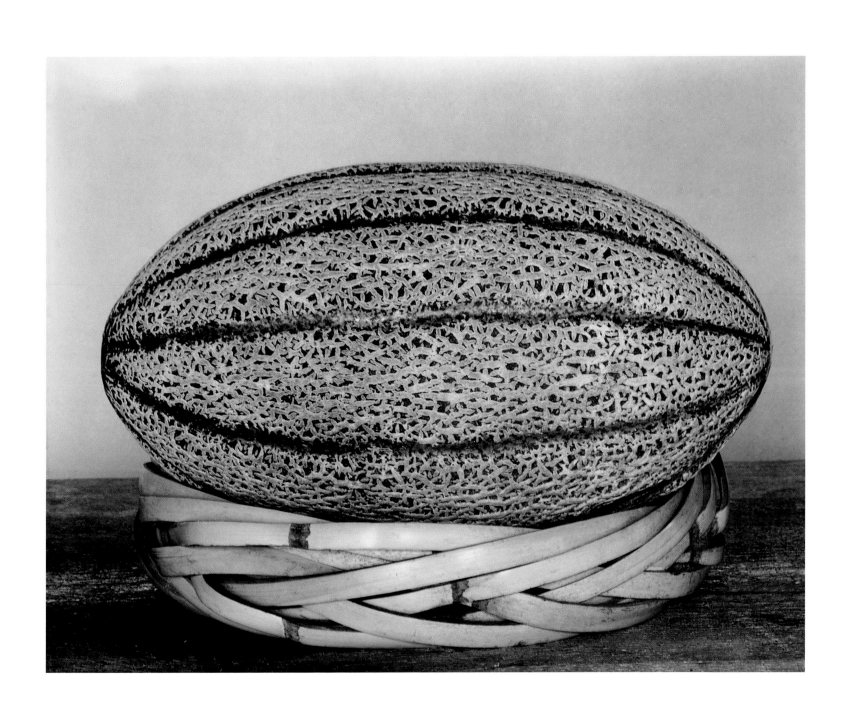

Melon, 1927
Gelatin silver print
18.7 x 23.9 cm
Center for Creative Photography, University
of Arizona, Edward Weston Archive
Printed by Cole Weston, supervised

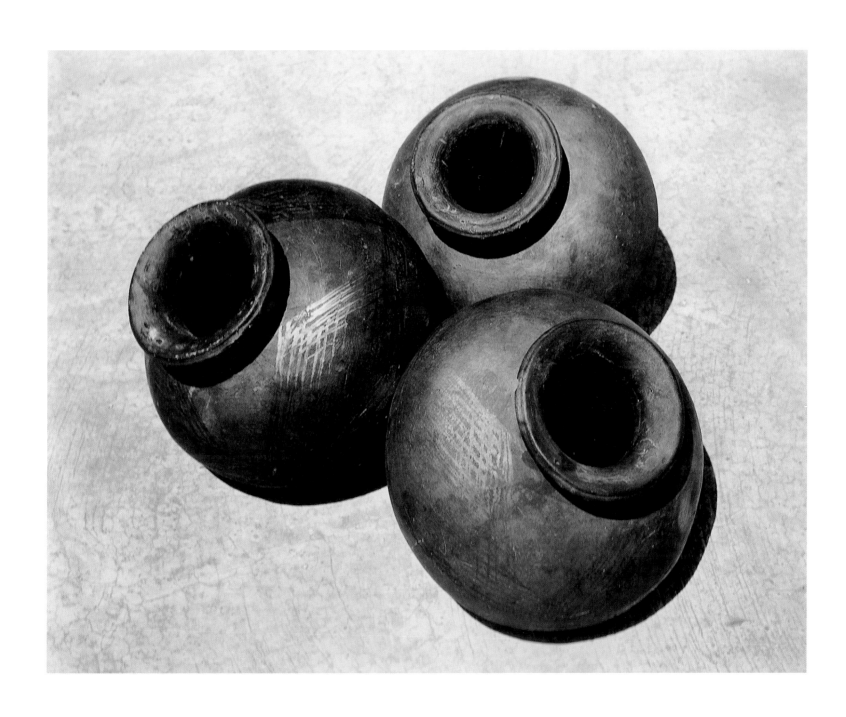

Tress Ollas, 1926
Gelatin silver print
19.1 x 24.1 cm
Margaret Weston Collection

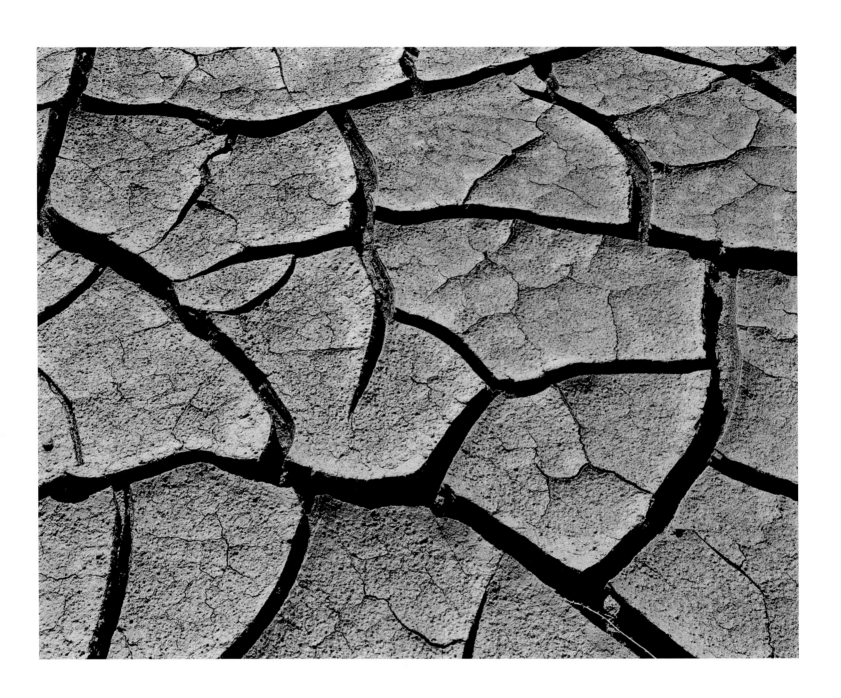

Cracked Earth, Borrego Desert, 1938
Gelatin silver print
19.1 x 24.2 cm
Center for Creative Photography, University
of Arizona, Edward Weston Archive
Printed by Brett Weston, supervised

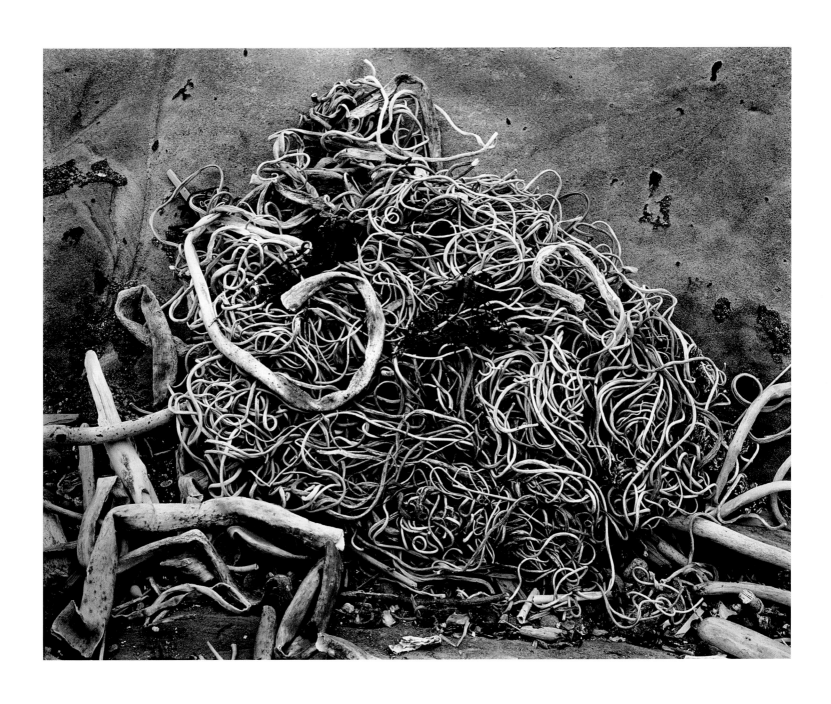

Dried Kelp, Point Lobos, 1940
Gelatin silver print
19.3 x 24.3 cm
Center for Creative Photography, University
of Arizona, Edward Weston Archive

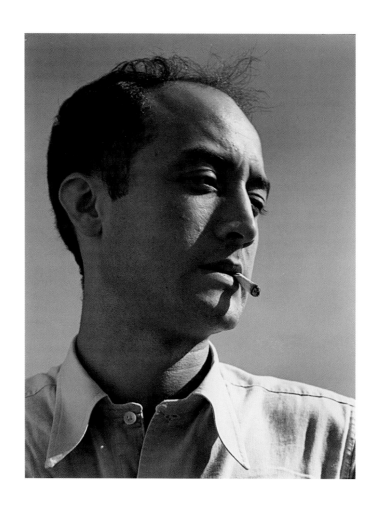

Isamu Noguchi, 1935
Gelatin silver print
11.8 x 9.3 cm
Center for Creative Photography, University
of Arizona, Edward Weston Archive

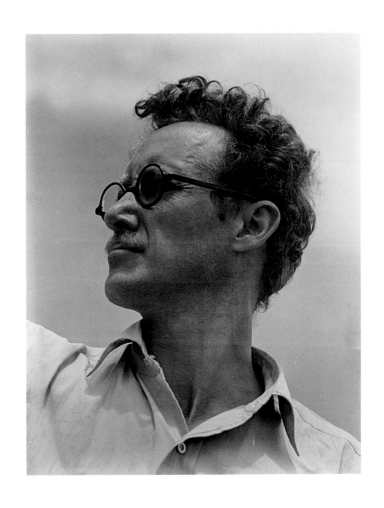

Arthur Millier, 1935
Gelatin silver print
11.7 x 9.2 cm
Center for Creative Photography, University
of Arizona, Edward Weston Archive

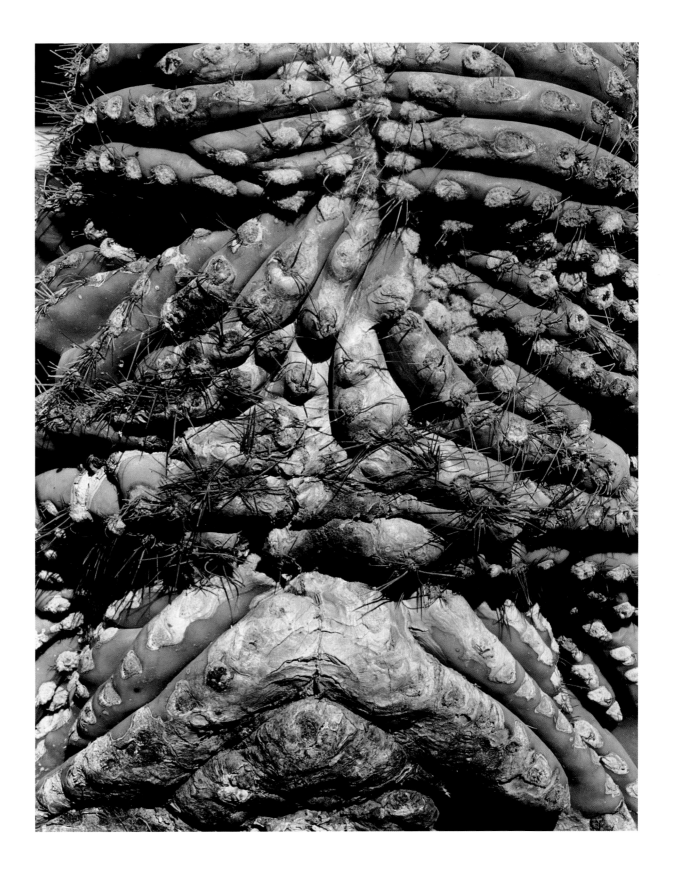

Cacti, 1932
Gelatin silver print
24.2 x 19.1 cm
Center for Creative Photography, University
of Arizona, Edward Weston Archive

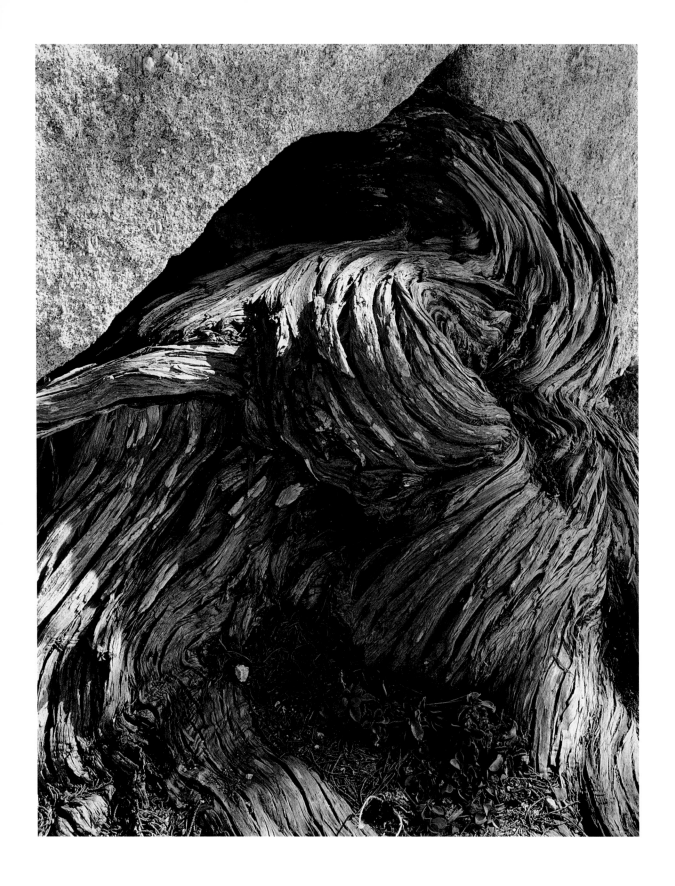

Cypress Root, Pebble Beach, 1929
Gelatin silver print
23.9 x 18.9 cm
Center for Creative Photography, University
of Arizona, Edward Weston Archive
Printed by Brett Weston, supervised

130

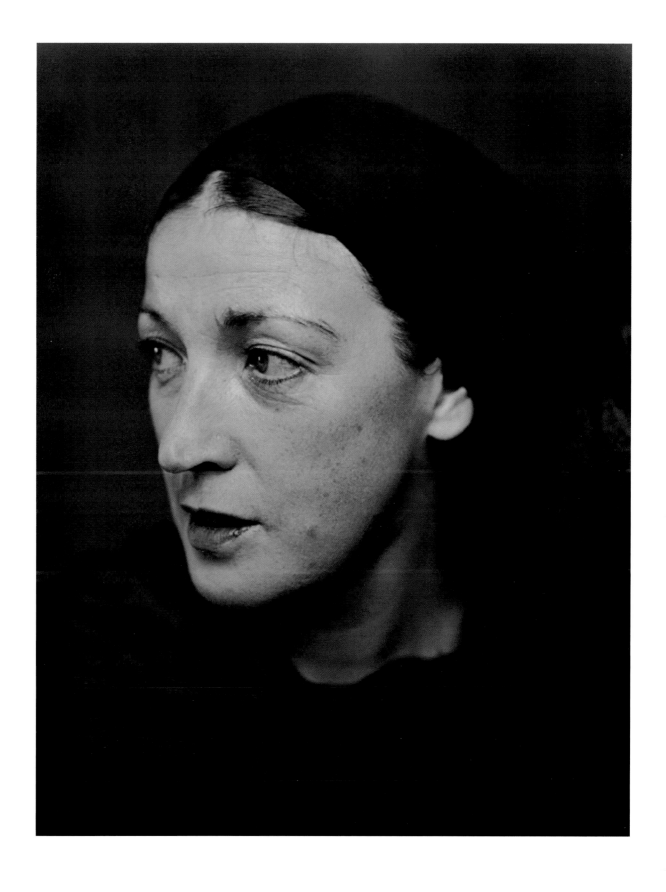

Claire Spencer, 1934
Gelatin silver print
24.4 x 19.1 cm
Center for Creative Photography, University
of Arizona, Edward Weston Archive

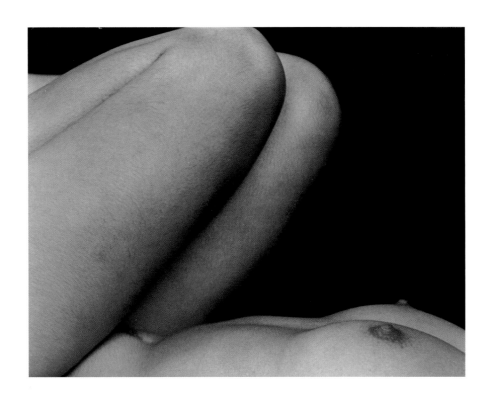

Nude, 1934
Gelatin silver print
9.3 x 11.9 cm
Center for Creative Photography, University
of Arizona, Edward Weston Archive, Gift
of the Heirs of Edward Weston

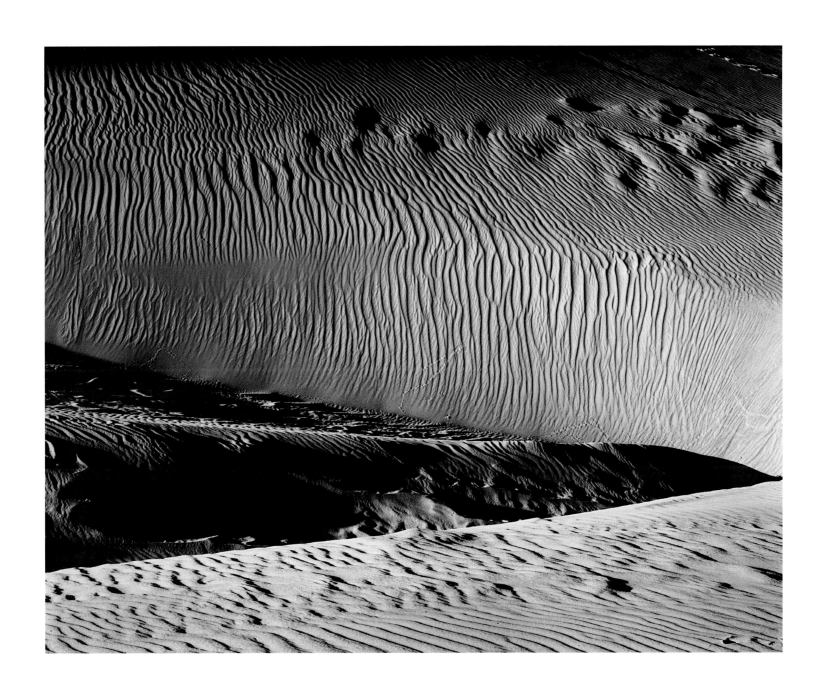

Dunes, Oceano, 1936
Gelatin silver print
19.3 x 24.3 cm
Center for Creative Photography, University
of Arizona, Edward Weston Archive
Printed by Brett Weston, supervised

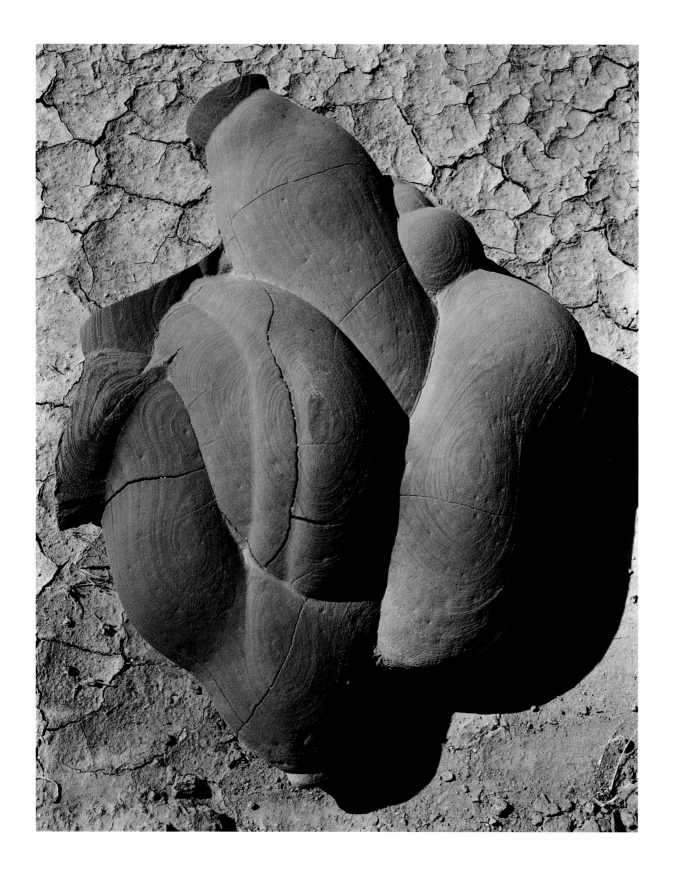

Concretion, Salton Sea, 1937
Gelatin silver print
24.2 x 19.1 cm
Center for Creative Photography, University
of Arizona, Edward Weston Archive

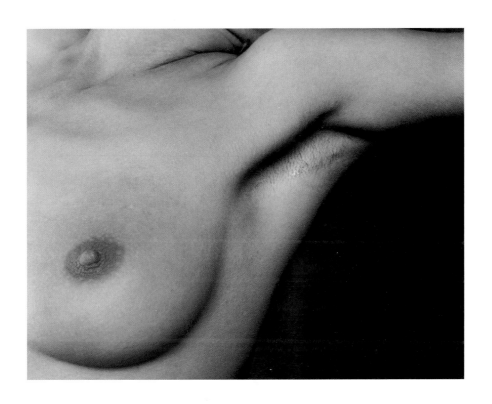

Nude, 1933
Gelatin silver print
9.3 x 11.8 cm
Center for Creative Photography, University
of Arizona, Edward Weston Archive, Gift
of the Heirs of Edward Weston

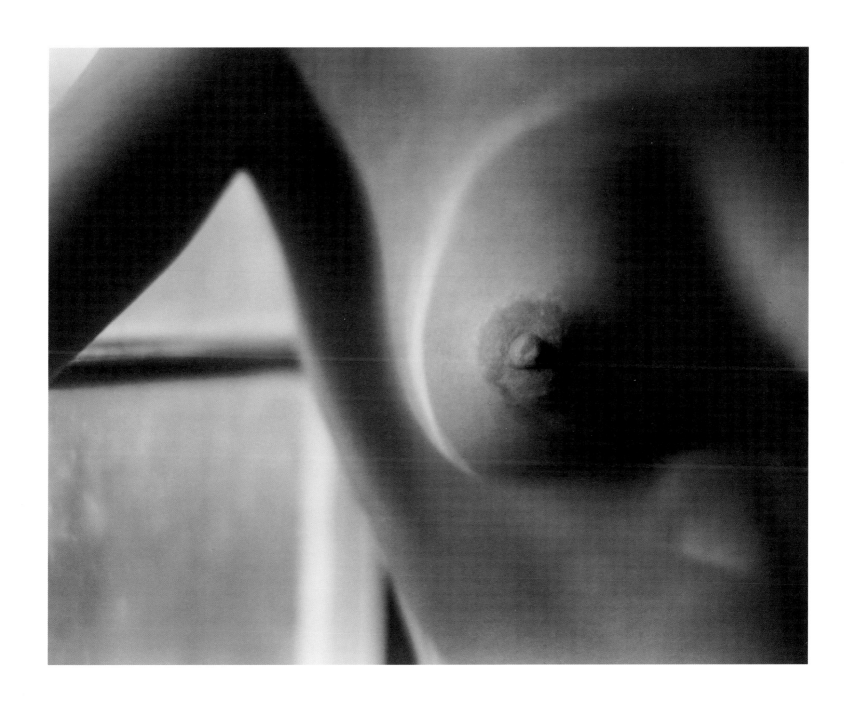

Breast, 1920
Platinum print
18.6 x 23.7 cm
Center for Creative Photography, University
of Arizona, Gift of Irving W. Rose
Printed by Cole Weston, unsupervised

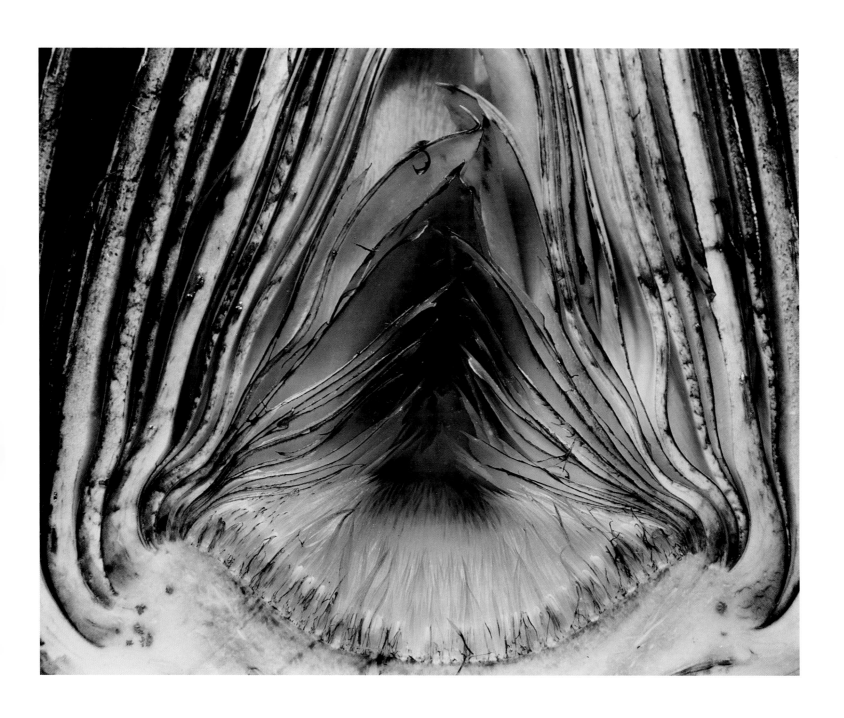

Artiche Halved, 1930
Gelatin silver print
18.9 x 23.6 cm
Center for Creative Photography, University
of Arizona, Edward Weston Archive, Gift
of the Heirs of Edward Weston
Printed by Brett Weston, supervised

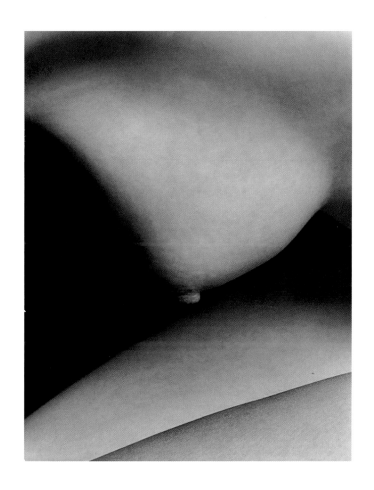

Nude, 1934
Gelatin silver print
11.4 x 9.1 cm
Center for Creative Photography, University
of Arizona, Edward Weston Archive

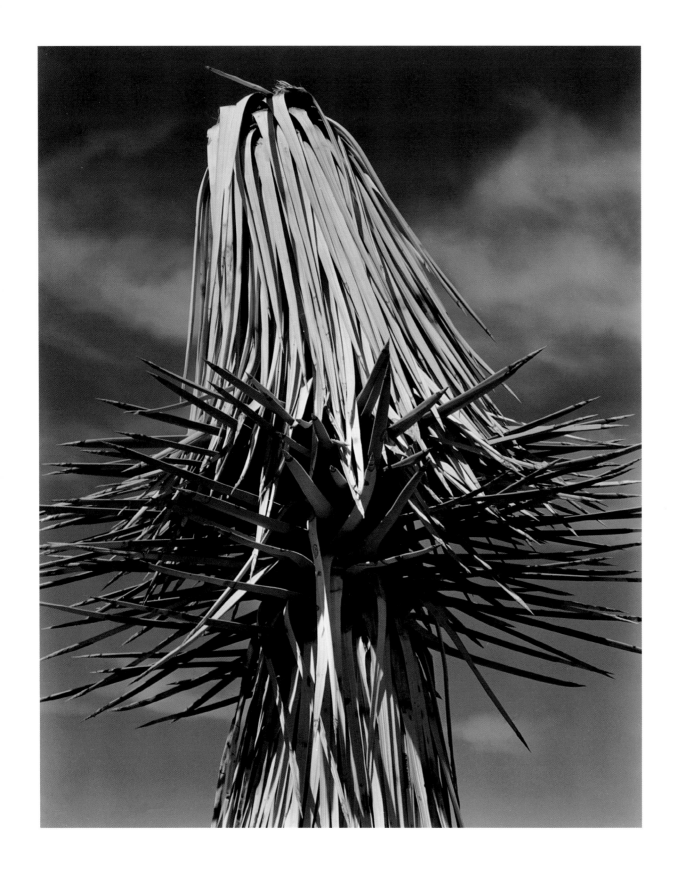

Joshua Tree, Mojave Desert, 1937
Gelatin silver print
24.2 x 19.1 cm
Center for Creative Photography, University
of Arizona, Edward Weston Archive

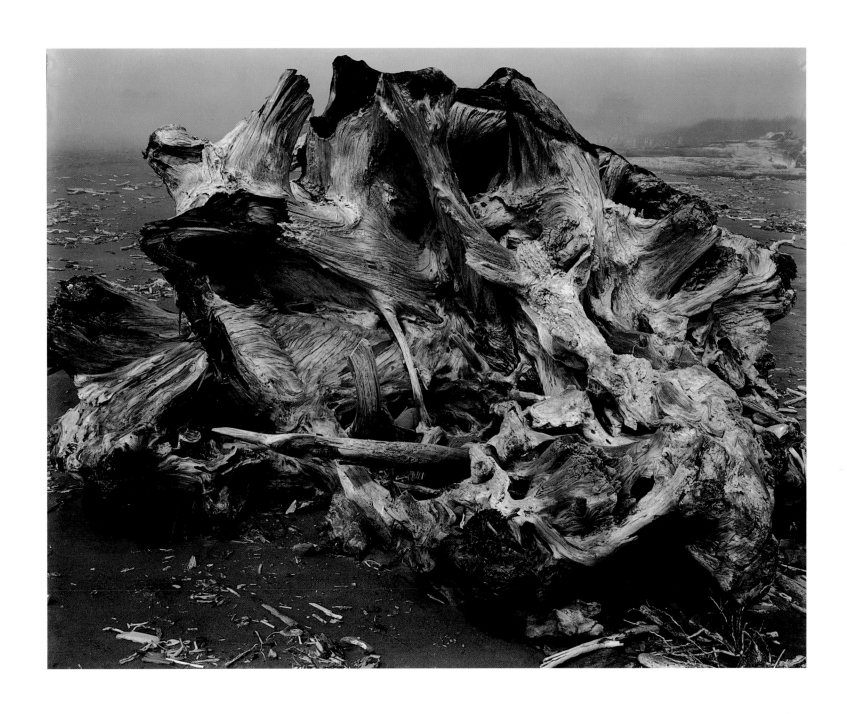

Drift Stump, Crescent Beach, 1937
Gelatin silver print
19.2 x 24.5 cm
Center for Creative Photography, University
of Arizona, Edward Weston Archive
Printed by Brett Weston, supervised

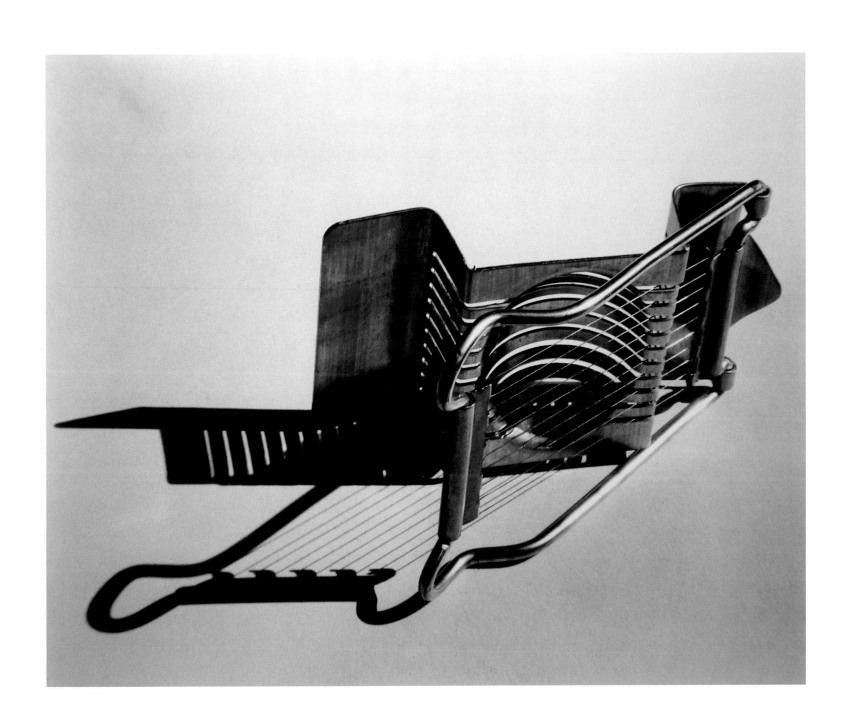

Egg Slicer, 1930
Gelatin silver print
19.1 x 24.1 cm
Margaret Weston Collection
Printed by Cole Weston

Edward Weston, a Biography Raisonné

by Chiara Dall'Olio

A man with a great charm, a sharply penetrating gaze and a certain dose of cynicism, not a wayward genius, a passionate man, capable of both overwhelming love and great detachment, Edward Henry Weston was born on March 24, 1886 in Highland Park, a suburb of Chicago, Illinois. He spent most of his childhood in Chicago, where he attended Oakland Grammar School. When he was sixteen his father gave him a camera—a Kodak Bull's Eye #2—and from that day on he never stopped taking pictures. The first subjects that drew his interest were the parks of Chicago and his aunt's farm. Just four years later, in 1906, one of his photographs was published in the magazine *Camera and Darkroom*. In the same year Weston moved to California.

After working for a short time as a surveyor for the San Pedro, Los Angeles and Salt Lake railroads, he became a traveling photographer. He plied his trade door-to-door, offering to take pictures of children, pets, and funerals in postcard format: 12 prints for 1 dollar. Realizing the need for formal training, in 1908 Weston went back East and attended the Illinois College of Photography in Effingham. He completed the twelve-month course in just six months and then headed right back to California. In Los Angeles he was employed as a retoucher by George Steckel, who ran a portrait studio.

In 1909 he was employed at the portrait studio of Louis A. Mojoiner. His first works already showed his great talent at using lighting and composition.

That same year he married Flora May Chandler, and they had four children: Edward Chandler (1910), Theodore Brett (1911), Laurence Neil (1916) and Cole (1919). Edward and Flora were divorced in the late 1930s.

In 1911 Weston opened his own portrait studio in the Los Angeles suburb of Tropico (now Glendale), which would be his operative base for the following two decades. Although most of his work involved portrait photography, he also began to produce more personal works and earned his first acknowledgements Weston owed his first success to his work with a soft-focus lens and his romantic portraits, which featured evanescent tones that were distinctively pictorial-style and an overtly strong sensitivity to light and form. Like his fellow-photographers from the West Coast, he was also inspired by the Japanese art that so greatly influenced Art Nouveau in those years.

Between 1914 and 1917 he won many prizes at the international salons and also had the privilege of being invited to and becoming an honorary member of the London Salon of Photography, which had succeeded The Linked Ring, one of the founding institutions of European pictorialism. Articles about his work were published in such magazines as *American Photography*, *Era Photo* and *Photo Miniature*. Weston himself contributed many of his own articles to these periodicals.

In 1912 he met the photographer Margrethe Mather who became his studio assistant as well as his most frequent model for about the next decade. He taught her photography and she introduced him to modern art. Margrethe is the subject of some of the most beautiful pictorialist portraits of the first decade of the century. She had a strong influence on Edward, and he would later describe her as "the first important woman in my life."

The many affairs Weston is known for—with Margrethe Mather, Tina Modotti, Sonya Noskowiak, Charis Wilson—were not just sentimental. From each one of these outstanding women he drew inspiration and found a new approach to photography. One might say that each woman marked a turning point in his artistic career: Margrethe marked the transition from pictorialism to straight photography; with Tina he began

to photograph everyday objects and ponder the relationship between realism and abstraction; Sonya founded with Edward (and with others) Group f/64; and Charis would accompany him on the trips he took thanks to his Guggenheim Fellowship; she also wrote the texts that described his images, and contributed greatly to the presentation of his work, as well as being the subject of some of his most famous nude photographs. Starting in 1915 Weston began to keep diaries—which he called "daybooks," the whole collection of which was published in 1973—that chronicled his life and the development of his art.[1]

In 1922, while traveling to visit his sister May, Weston photographed the Armco steel plant in Middletown, Ohio. These pictures marked a further turnaround in his career. Indeed, during that period he gave up the pictorialist style once and for all, in favor of a new emphasis on the abstract form and sharper resolution of detail. The industrial images were perfect examples of straight photography; they were direct, and true to reality. However, Weston never disavowed his pictorialist period, which he simply saw as being his point of departure. In 1944 he wrote: "Can anyone say where and when the 'Pictorialist' & 'Purist' part ways? … I can honestly say that I never based my way of seeing on moral grounds. I just think—today—that there is nothing so beautiful as sharp, long scale, glossy photograph. But tomorrow? I have a sneaking suspicion that someday I'll throw my 'fans' into utter confusion by making a series of soft focus negatives, just to contradict myself and say 'it can be done'."[2]

In 1922 Weston went to New York where he met Alfred Stieglitz, Paul Strand, Charles Sheeler and Georgia O'Keeffe. All these artists encouraged him in the new direction of his work. By looking at Georgia O'Keeffe's portraits and the first pictures of clouds that Steiglitz had taken just a few months earlier, Weston had the feeling that a new dimension of photography was being born. He later wrote, in regard to the two trends—abstraction and realism—that were beginning to appear in his own works: "The camera should be used for a recording of *life*, for rendering the very substance and quintessence of the *thing itself*, whether it be polished steel or palpitating flesh. … I shall let no chance pass to record interesting abstraction, but I feel definite in my belief that the approach to photography is through realism."[3]

In 1923 Weston moved to Mexico with his eldest son Chandler and Tina Modotti, whom he had met in Los Angeles, and had become his model and lover. Tina, who came from a family of Friuli (Italy) immigrants, was an actress, but she abandoned her career to follow Weston and dedicate herself to photography and political engagement in the communist revolution first in Mexico, and later in Spain and Russia. They stayed in Mexico almost interruptedly until 1926, when Edward definitively moved back to the United States.

While in Mexico, Weston, together with his son, opened a photographic studio in Tacubaya and another one in Mexico City. Many of his most important portraits and nudes were taken during that period, which is also when he met the renowned artists of the Mexican Renaissance movement, Diego Rivera, David Siqueiros and José Orozco, who regarded him as being a master of twentieth-century art. For Weston the period he spent in Mexico was a time of transition and self-analysis which led him to focus on geometric composition, on the relationship between reality and abstraction, and to move his camera closer to the subject itself.

On April 14, 1926 his diary reads: "In trying to analyze my present work as compared to that of several years ago, I can best summarize that once my aim was interpretation; now it is presentation."[4]

Those were the years when he clearly understood one aspect, perhaps the key aspect of his way of seeing photography: the photographer must visualize the picture inside even before taking it, he must imagine and have a clear idea of the finished result even before pressing the shutter button.

"Unless I pull a technically fine negative, the emotional or intellectual value of the photograph is for me almost negated. ... The real test of not only technical proficiency, but intellectual conception, is not in the use of some indifferent negative as a basis to work from, but in the ability to see one's finished print on the ground glass in all its desired qualities and values before exposure."[5]

After Weston returned to California in 1926 he began to create the photographs that would distinguish him in the years to come and thanks to which today he is still one of the most highly rated artists on the modern photography market. Take, for instance, his vegetables and shells whose rich sculpture-like textures he succeeded in bringing out; the details of object's surfaces; the nudes, often only partially viewed, depicted with abstraction and refined sensuousness.

In 1928 in San Francisco Weston opened another studio, with his son Brett this time, and that same year, he took his first pictures of California, which he published in 1940 in the volume *California and the West*.

In 1929 he moved to Carmel, a town in California whose inhabitants were mostly artists, and he discovered Point Lobos: after Mexico this site marked another turning point in his research. Beaumont Newhall in *The History of Photography* wrote: "Weston developed [his] approach to the point of virtuosity. He demanded clarity of form, he wanted every area of his picture crystal-clear, with the substances and textures of things appreciable to the point of illusion.

The fact that the camera can see more than the unaided eye he long regarded as one of the great miracles of photography. In a Weston landscape, everything is sharp from the immediate foreground to the extreme distance ... His vision led him to a straight, often brutally direct approach that made use of the phenomenon with powerful effects."[6]

Weston simplified his working method, preferring to make contact prints from negatives rather than enlargements, with results that were perhaps less spectacular in terms of size, but more elegant and closer to perfection, almost as though they were small gems. He preferred gelatin silver print on glossy paper, which rendered the details perfectly, to the platinotype from the years before, which softened the outline and offered opaque results similar to charcoal drawings. He replaced his expensive soft-focus lens with a sharply cutting rapid rectilinear lens. The sign in his studio window in Carmel read: "Edward Weston, Photographer, Unretouched Portraits, Prints for Collectors."

In those years Weston became romantically involved with Sonya Noskowiak who, like Margrethe and Tina before her, also worked as his assistant and model. For the following five years they shared the art of photography.

In 1932 Weston was one of the charter members of Group *f*/64, along with Ansel Adams, Willard Van Dyke, Imogen Cunningham, John Paul Edwards, Sonya Noskowiak and Henry Swift. The group chose as its name the technical term *f*/64, the smallest aperture available on the lens of large-format cameras used at the time to secure great depth of field and maximum image sharpness of both foreground and distance. The members of the group formulated a very strict aesthetic: any photograph not sharply focused in every detail, not printed by contact on glossy black-and-white

paper, not mounted on a white card, and betraying any handwork or avoidance of reality in the choice of subject was "impure." The group reacted violently to the weak, sentimental style then popular with pictorial photographers in California. The Group f/64's first show was in San Francisco in 1932 and for a few years it was the most avant-garde group in the United States. Still in 1932 Merle Armitage published *The Art of Edward Weston.*

Those were the years of the Great Depression in America. The rural crisis in the American Midwest encouraged thousands of people to abandon their land and migrate to California, the only state that had not been so hard hit by the droughts, their hope being to find work as laborers. A number of photographers were hired by the Farm Security Administration (including Dorothea Lange) to document the migrant workers' conditions. Weston also worked for the US Government in 1933, but his work concerned the architecture of Monterey in New Mexico and the open landscape.

Although Weston promoted realism in photography, he was never interested in documenting the society around him. In the words of Olivier Lugon: "The conquest of the details does not serve as much to see the photographic reality more and better, as it does to produce images with a richer tonal quality, texture and surface."[7]

In 1934 Weston met Charis Wilson, the nineteen-year-old daughter of H. R. Wilson, a famous novelist and humorist. She too became Weston's model, lover and life companion. Not long after he met Charis they moved to Santa Monica to live with his son Brett. Weston opened another photographic studio there. Between 1934 and 1936 Weston began to photograph a remarkable series of nudes and sand dunes in Oceano, California. Also in 1936 Weston was the first

photographer to apply for and receive a Guggenheim Fellowship for his experimental work. He spent the next two years taking pictures in the western and southwestern United States together with Charis Wilson, who kept a journal of their travels. For Weston it was an unrepeatable experience: for years he had had to make time for his art and now at last he could dedicate himself to it completely, without worrying about financial obligations. Weston in fact supported himself with the work he did in his studio, which was mostly portraits and services on commission in which his genius often clashed with the average public's taste. His photographs of peppers, shells and dunes were his own personal research, admired in artistic environments, but perhaps too innovative to enjoy the appreciation, even at a commercial level, of the public at large.

In 1937 his wanderings in the West led him to Yosemite National Park and to his friend Ansel Adams. He stayed there a week and together they took pictures. Although both men were convinced of the need to realize pure images, technically perfect ones in which nature in all its forms has the lead role, the differences between their two styles were evident: the drama and the poetry of the skies looming over the broad views of valleys and mountains were Adams' work, while the details of the surfaces and the forms of nature rendered in geometric abstraction were Weston's.

At the end of his two years of traveling for the Guggenheim project (the Fellowship was renewed for 1938), Edward had traveled 35,000 miles and taken more than 1,500 negatives. Now it was a question of finding a place to stop and print the results of this remarkable experience. So in 1938 he settled in Wildcat Hill near Carmel, in the house his son Neil had built overlooking the ocean, and that would become

his residence-cum-workshop until his death. One year later he and Charis Wilson were married.

In 1940 the photographs taken by Edward Weston and the journal written by Charis Wilson during their journeys for the Guggenheim project were collected and published in the book *California and the West*. Encouraged by the volume's success, the following year they set out for the eastern and southern United States, to produce images that would be used to illustrate the new edition of *Leaves of Grass* by the poet Walt Whitman. Weston was not nearly as enthusiastic about this experience as he had been about the previous one, probably also due to the fact that the couple was not getting along. They were divorced in 1945.

During World War II Weston collaborated with the air surveillance service at Yankee Point, a high cliff near Carmel overlooking the Pacific Ocean.

In 1946, Weston began to suffer from the first symptoms of Parkinson's disease, and in 1948 he took his last photograph at Point Lobos. In 1946 New York's Museum of Modern Art organized a major retrospective of his work curated by Nancy Newhall.

Some three hundred prints were showcased.

Over the next ten years Weston became increasingly disabled by his illness. During that time he supervised the printing of his photographs by his sons Brett and Cole. A portfolio to commemorate the fiftieth anniversary of his career was published in San Francisco in 1952, accompanied by twelve photographs printed by Brett. The last project Edward Weston worked on between 1952 and 1955 is known as *Project Prints*. Edward selected 832 negatives among all those taken, considering them as the most representative of his career, and he had Brett print them in groups of 8–10 prints each.

In 1956 the large exhibition *The World of Edward Weston*, curated by Beaumont and Nancy Newhall, was held at the Smithsonian Institution. It was a tribute to his great success in American photography.

Edward Weston died at the age of 71 on January 1, 1958. He was seated in an armchair in his home on Wildcat Hill gazing at the sun coming up over the ocean. From Pebbly Beach at Point Lobos his ashes were scattered in the Pacific Ocean.

Sources
Edward Weston Biography © Copyright 2005 – Cole Weston.
Beaumont Newhall, *The History of Photography* (New York: The Museum of Modern Art, 1982).
The Daybooks of Edward Weston, Vol. I: Mexico, Vol. II: California, edited by Nancy Newhall (Millerton, New York: Aperture, 1973).
Eloquent Nude. The Love and Legacy of Edward Weston and Charis Wilson, directed by Ian McCluskey (NW Documentary, 2007).
David Travis, "Continuez a travailler. L'influence d'Alfred Stieglitz sur la photographie Américaine après les années 1920," in *New York et l'art moderne. Alfred Stieglitz et son cercle [1905–1930]*, exhibition catalogue, Paris, Musée d'Orsay, 2004.
Roberta Valtorta, *Il pensiero dei fotografi. Un percorso nella storia della fotografia dalle origini a oggi* (Milan: Mondadori, 2008).
Roberta Valtorta, *Volti della fotografia. Scritti sulla trasformazione di un'arte contemporanea* (Milan: Skira, 2005).
Olivier Lugon, *Lo stile documentario in fotografia. Da August Sander a Walker Evans 1920–1945* (Milan: Electa, 2008).
Dizionario della fotografia, edited by Robin Lenmann and Gabriele d'Autilia (Turin: Einaudi, 2008).
Edward Weston, exhibition catalogue, edited by Paolo Constantini, Venice, Palazzo Fortuny, 1990 (Florence: Edizioni Alinari, 1990).
Edward Weston, The Flame of Recognition, edited by Nancy Newhall (Millerton, New York: Aperture, 1975).

Notes
[1] In 1923 Weston burned all the diaries he had written until then, except for six or seven pages, although he never stopped keeping them. When, in 1940, it was suggested he publish all of them, he censored some of the names and comments using a razor to scratch them out so that some of the pages show just blank strips.
[2] *Edward Weston, The Flame of Recognition* 1975, p. 82.
[3] Newhall 1982, pp. 184–88.
[4] *Edward Weston, The Flame of Recognition* 1975, p. 18.
[5] Newhall 1982, p. 188.
[6] Newhall 1982, pp. 258–60.
[7] Lugon 2008, p. 147.